Colored Pencil Portraits
Step by Step

ANN KULLBERG

NORTH LIGHT BOOKS
CINCINNATI, OHIO

ABOUT THE AUTHOR

Ann Kullberg, a self-taught artist, received a degree in education from Pacific Lutheran University in Tacoma, Washington. After discovering colored pencils in 1987, she devoted herself to art and portraiture. Her work has been published in *Creating Textures in Colored Pencil, Creative Colored Pencil,* the American Society of Portrait Artists' *Portrait Signature* magazine, and in several volumes of *The Best of Colored Pencil.* She has conducted numerous workshops in the Pacific Northwest and throughout the country. Ann invites you to visit her portrait web site at: http://www.prtraits.com/kullberg.

Other fine North Light Books are available from your local bookstore, art supply store or direct from the publisher.

09 08 07 06 05 5 4 3 2 1

Library of Congress has cataloged the hardcover edition as follows:

Kullberg, Ann
 Colored pencil portraits step by step / Ann Kullberg—1st ed.
 p. cm.
 Includes index.
 ISBN 0-89134-844-1 (hardcover : alk. paper) ; ISBN 1-58180-639-6 (pbk : alk. paper)
 1. Colored pencil drawing—Technique. 2. Portrait drawing—Technique. I. Title.
NC892.K86 1998
743.4'2—dc21 98-19181
 CIP

Editor: Jennifer Long
Production editor: Nicole R. Klungle
Designer: Angela Lennett Wilcox

F+W PUBLICATIONS, INC.

DEDICATION
To Katie, my babydoll

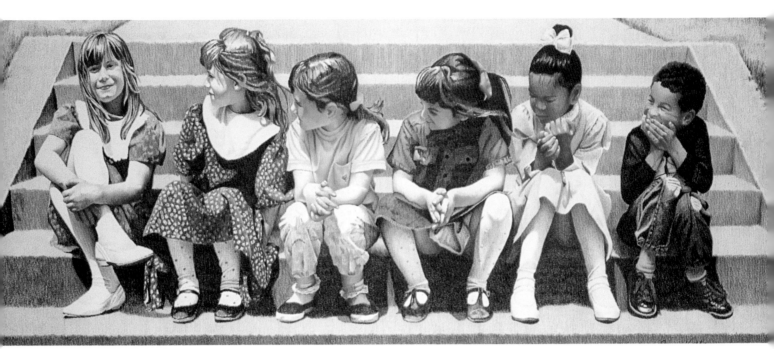

THE SECRET
30″ × 12½″ (75cm × 31cm)

ACKNOWLEDGMENTS

I owe this book and all else I've accomplished with my art to the two people who bought me boxes of crayons and little watercolor sets in the sixties, when the budget was already stretched too tight and there really was no extra money . . . who paid electric bills in the eighties when gallery sales were slow . . . who wired mortgage payments in the nineties when there were no portrait commissions . . . who continued to believe in me when most would finally have given up. From my heart, thank you Mom and Dad, thank you.

And there are others to thank: my brother, Phil, for being my first customer; my sister, Marylou, for happily accepting art as payment for outstanding loans; all the friends and family who encouraged and helped me through the years; the fine editors and staff at North Light Books who made this book possible; and finally, Vera Curnow, friend and founder of the Colored Pencil Society of America, for cheerfully and enthusiastically answering all my way-too-many questions.

TABLE OF CONTENTS

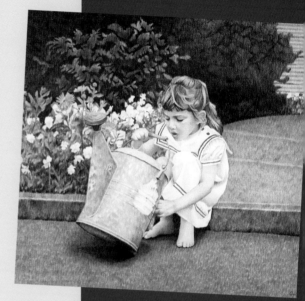

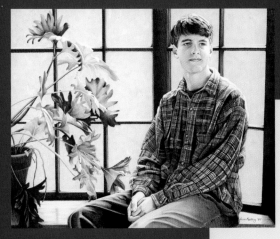

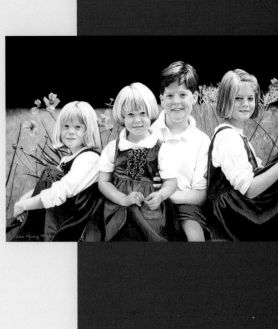

INTRODUCTION

In grade school I was frustrated with colored pencils and crayons. Crayons put down lots of rich color but were never sharp enough for detail. Craft-grade colored pencils could be nice and sharp, but no matter how much pressure I used, the color was pale and lifeless. Mind you, I didn't lose sleep over any of this—I just wished my little maps of Uruguay's mountain ranges and major rivers could have a little more *oomph*. Little did I know that someday I'd be making my living with just the sort of tool I wished for in fifth grade!

When I did pick up my first professional-grade colored pencils around 1988, I admit I immediately felt I was *home*. This was it. This was a medium I could do something with. No time-consuming setup. No messy cleanup. No toxic fumes or dust. No stretching. No color mixtures turning to mud. No expensive surfaces and supplies. I could draw for ten minutes, heat a baby bottle, draw for twenty more and change a diaper. Life was good.

Then I stumbled onto portraiture and life got better. Who could complain about a career that allows you to travel to beautiful homes, meet darling children, then go home and draw to your heart's content, ten feet from your kitchen and in your slippers? What could be more satisfying than doing what you love, and knowing that what you have produced has already become a family heirloom? Just when I thought it couldn't get better, I received the thrilling opportunity to write this book. I love teaching almost as much as I love making art, so now I guess I've reached nirvana.

Some of you are new to colored pencil and still can't quite believe the quality of work the medium can produce. Others of you already know what can be done with colored pencils but haven't yet tried them out on a portrait. I've attempted to address both the inexperienced and experienced in this book. For the novice, I begin with the most basic information about materials and colored pencil techniques. For the initiated, I offer a step-by-step progression through all the elements that go into a portrait. It is very important to me that I really *show* these steps, so in my demonstrations I've included as many progressions as possible.

You may find that many of the demonstrations I've included in this book look different from those in most art instruction books. As a working portrait artist, I decided to include step-by-step demos of actual commissioned works in progress, rather than create something specifically for the different sections of this book. Consequently, many of the demos show areas not specifically addressed in the text. I trust that rather than confusing you, this will add to your use and understanding of the material presented.

Finally, a word of warning. This book presents the methods *I* use to paint a portrait; it does not attempt to decree how *you* should paint a portrait! Please take all of the following information as a guideline and not a formula. There are as many perfectly legitimate ways to paint a colored pencil portrait as there are colored pencil artists. Consider this only one path on your journey to finding your own way.

Ann Kullberg

OCTOBER MORNING
20″ × 27″ (51cm × 69cm)
Collection of Alan Yates and Linda Tweedie

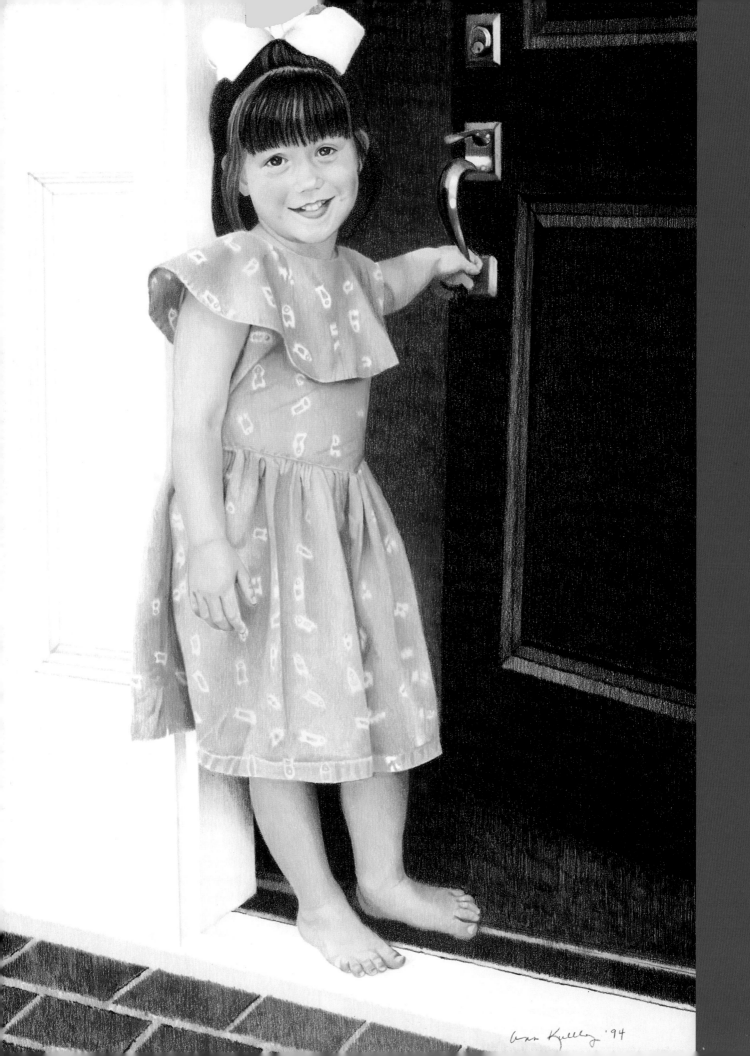

Getting Started

The beauty of colored pencil is that it takes so little to get started: pencils, paper and a few minimal tools and you're on your way. There's no setup, no cleanup, no health concerns, and on top of that, it's very affordable. You also need little space to set up your colored pencil studio; in fact, for years I worked in a tiny four-foot-square area stolen from the family room, behind the sofa!

KATE
18" × 22" (45cm × 55cm)
Collection of Mark and Debbie Madden

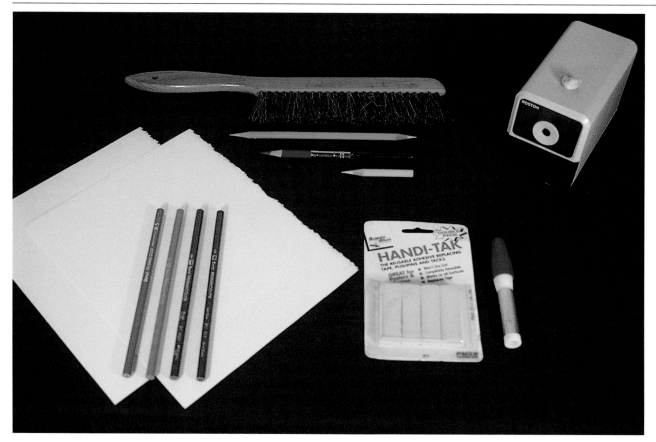

Everything you need to get started

Paper

Over the years, I've tried dozens of papers and have finally settled on one called Stonehenge, which is manufactured by Rising. It is a wonderful paper I guarantee you'll fall in love with. It's strong, clean and inexpensive. There are few decisions to make with Stonehenge as it only comes in one surface and one weight. All you need to know is the size and color you prefer. I use plain white, although it comes in several shades of white, off-white and cream. You can buy it by the sheet or in smaller pads of fifteen or so sheets. I confess it's a little hard to find if you don't have a well-stocked art supply store in your area, but it can be ordered from most of the larger art supply catalogs. Even with the loads of layers and heavy pressure I apply, this paper holds up beautifully. You won't be sorry if you take the time to find it.

Pencils

I started using Sanford Prismacolor pencils ten years ago; by now I know them much better than I know my own children! Prismacolor pencils have the widest color range, with 120 colors available, and are by far the most widely used colored pencils. This isn't to say there's anything wrong with the other brands, although I would definitely stay away

from any "student-grade" pencil. It's simply that I have found I can do all I want to do with Prismacolor pencils, so I've stuck with them. If you're just starting out, I suggest you buy a set of at least forty-eight—but preferably seventy-two—colors. In most art stores, you can buy individual colors you'd like that aren't included in the set.

HINT

Several years ago, Sanford changed the color names of several of its Prismacolor pencils. Throughout the book, I will use the newer color names, so for those of you with older pencils, here is a list of the old names and their replacements.

- *Flesh is now Peach.*
- *Light Flesh is now Light Peach.*
- *Sand is now Jasmine.*
- *Raw Umber is now Light Umber.*
- *Burnt Umber is now Dark Umber.*
- *Blush is now Blush Pink.*

Pencil Sharpener

I've given enough workshops around the country to have heard all the reasons people give for using handheld sharpeners, but I haven't heard one yet that persuades me to give up my Boston electric sharpener. To me, it is as essential as the pencils themselves! Handheld sharpeners take too much time, are messy and often chew up the wood. Battery-operated sharpeners are fine for workshops where you don't want to worry about the availability of electrical plugs; but for the studio, there's nothing like an electric sharpener. They're inexpensive at the large office supply stores, they're quick and they offer a beautifully sharp point (provided you *use* it often enough—but we'll get to that later). Every electric sharpener manufacturer puts a disclaimer on the box stating the product is not intended for wax-based pencils, which, of course, Prismacolor pencils are. Ignore it. All it means is that your sharpener will wear out a bit more quickly than it would sharpening graphite pencils.

Drafting Brush

Another must. As you work with colored pencils, it is inevitable that tiny bits of pencil dust will fall on your paper. To help reduce the dust, keep a rag directly under the sharpener, lay the pencil on the rag after sharpening and give it a twist to wipe the tip. But no matter how careful you are, dust particles will get on your paper; if you don't brush them off, you'll eventually grind them into the paper with your hand. Constant brushing is essential. I simply cannot work without a brush. On average, I brush every three or four minutes!

"Sticky Stuff"

I suppose you've noticed what looks like a wad of chewing gum on top of the sharpener at left. That's one of my favorite tools—a blob of reusable adhesive, or what I call "sticky stuff." I keep it on top of my sharpener so I always know where it is. I show here a package of Handi-Tak reusable adhesive, which can be found at most office supply stores, but there are many different brands and they all work just fine.

So what do I do with my blob? For starters, I put a tiny bit on each of the four corners of the back of my paper so my work will stay on my tilted drafting table. The effect is similar to Velcro in that you can easily lift the paper off your drawing surface and stick it back on.

I also have a nickel-sized blob permanently stuck on the right side of my drafting table to hold my drafting brush. Before the blob, it seemed I was constantly looking for my brush. I'm willing to guess that the sticky stuff that holds my brush saves me close to an hour per portrait just in "brush-searching" time! Finally, sticky stuff is a great eraser. No matter how often you brush your piece, you'll still get "pencil grime" on your paper. Simply rolling a blob over those areas will completely clean them. It also works much better than a kneaded eraser when you want to lift pencil off your work. (You'll see an example of that later, in the section on technique.)

Pencil Extenders

As your pencil gets shorter, you lose control. And let's face it, if you're using colored pencil with its little tiny point, you're probably a control freak, at least when it comes to your art. Using a pencil extender is one way to regain control of a short pencil. But eventually, the pencil gets so short it no longer fits into the pencil sharpener. So now what? Throw out the stub? Not if you're frugal like me! It took me years, but I finally figured out a way to use nearly the *entire* pencil. Using a bit of superglue, I glue my stub and a new pencil of the same color end to end. This allows me to use almost the entire pencil, with minimal waste, and the bonus is that I always have two sharpened ends at my fingertips! Be sure to break off the stub just before you sharpen through to the new pencil. This will leave one flat end of the new pencil to be glued later. Don't sharpen past the stub, or you'll end up with one pencil sharpened at two ends, which will eventually be totally useless.

HINT

It takes a little while to get good at this gluing business. I've found it works best to apply a fairly generous amount to the end of the new pencil, touch the stub to that end, then set both pencils down for a bit. After about two minutes, the glue should be ready. Holding the two ends together for about ten seconds should do the trick! I much prefer a superglue pen for this application; it's not messy and doesn't clog up.

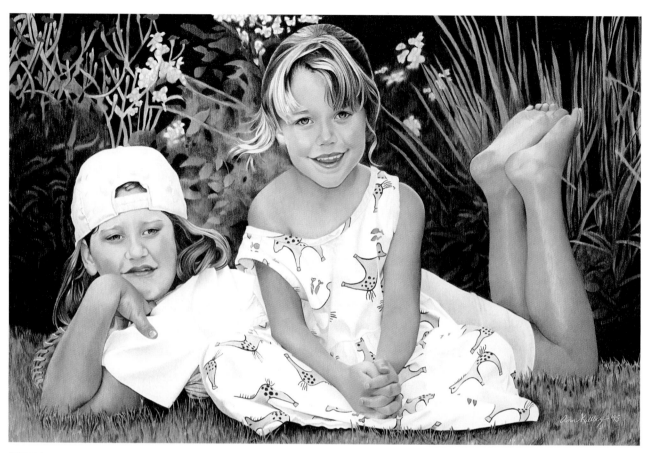

SISTERS
27" × 28" (67.5cm × 70cm)
Collection of Rob and Jody Harris

Getting to the Point

Imagine the tooth of your paper magnified many times and seen from the surface. What you would see are many hills and valleys. How many of those valleys your pencil will fit into is determined solely by the size of the point on your pencil. A tiny, sharp point will naturally fit into far more valleys than a large, dull point. The more valleys your pencil can fit into, the smoother the coverage and the smoother and more even your work will appear. Don't be any more reluctant to sharpen your pencil than a wood artisan is to carve away wood. Yes, you are chewing up your pencils and "wasting" perfectly good pigment every time you sharpen. The alternative is to make your pencils last a really long time while creating rough, uneven drawings!

The hills and valleys of the paper surface

Scumbling/"Brillo Pad" Technique

Although this technique is actually called *scumbling*, I call it my "Brillo pad" method since it's applied with a circular motion similar to the motion of your hand when using a Brillo pad to clean your pots and pans. Using a very sharp point and extremely light pressure, I move the pencil point in a circular (sometimes almost elliptical) motion, slightly overlapping as I move along. This technique allows maximum control of the pencil and creates the smoothest finish, but it is oh . . . so . . . slow. You can think of it as meditative and soothing or just plain tedious; either way, the "Brillo pad" technique is only for the patient, and it does take some practice to get your pressure consistent. The advantage is that you can get extremely subtle blending of color. For that reason I use this method for the face and hair of all my portrait commissions.

"Brillo Pad" Technique
For an even, tonal application such as this, use a well-sharpened point, very light pressure and a circular motion.

Sharpen, Sharpen, Sharpen!
If your tonal application looks like this, your point is not sharp enough. Consequently, the pencil is skipping over too many valleys and too much of your paper surface is showing through, creating a rough-looking texture.

Think Circular, Not Circles
When your circular motion is too large, as shown here, what you will see is a mass of coils that is anything but smooth! You don't have to get out your ruler, but just to give you an idea, each of my circular motions is about half a centimeter in diameter.

Vertical Line Technique

The vertical line technique I developed several years ago was born out of sheer desperation to find a way to work more quickly in colored pencil. With some experimentation, I found that a vertical stroke was a very natural movement for me, and that it was much quicker than the "Brillo pad" method. The vertical line technique is simply a vertical line next to another vertical line, next to another. The length of the line is usually determined by the space it is filling. A large space can take a longer line than a small space. As you work in vertical lines, you will notice there is some overlapping. Don't let that bother you. Since working in colored pencil means building up color with layer after layer of pencil, in subsequent layers you can even out the texture. You can also minimize the overlap by using a very light touch.

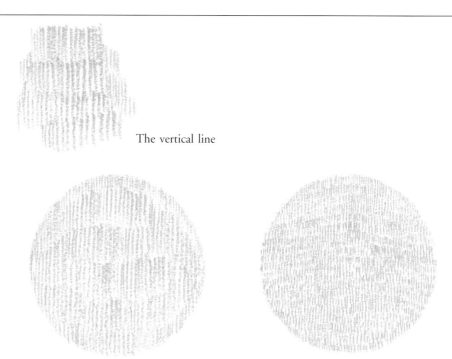

The vertical line

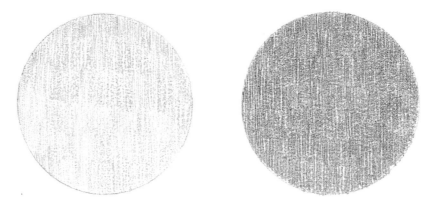

The left circle is an example of the vertical line technique done with an average stroke length. In the right circle, the strokes are too short, creating a choppy texture.

The left circle is an example of the vertical line technique using a very sharp point and extremely light pressure. In the right circle, the point is also very sharp, but here I've used medium to heavy pressure.

HINT

The longer the stroke, the less control you have, so in areas where you need a lot of control, your stroke will naturally have to be shorter.

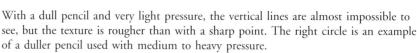

With a dull pencil and very light pressure, the vertical lines are almost impossible to see, but the texture is rougher than with a sharp point. The right circle is an example of a duller pencil used with medium to heavy pressure.

Edges

As with any art medium, there are times when you will want to create crisp, clean edges with your colored pencils and times when you want loose, rough edges. Generally, I want all of the edges of my subject to be crisp and the background and foreground edges to be rougher. This helps to pop the subject out and ensures the eye will see the subject as the center of attention.

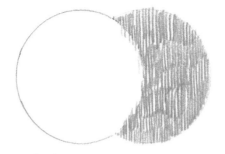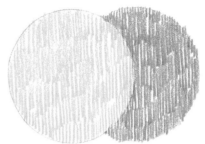

Rough Edges
No outlining needed here—simply follow the line of your shape with exaggerated strokes, letting the edges merge.

Smooth Edges

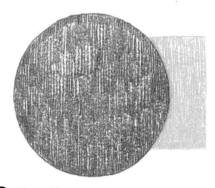

1 Outline the Shapes
Using the color of your first layer and a very sharp point, outline the shape. From this point on, you only have to work up to this outlined edge, which will help to avoid dragging dark colors into lighter areas.

2 Fill the Outer Edges
Using a very short stroke (for extra control), fill in *just up to the edge* of the outline.

3 Fill the Shape
Now you can finish filling in the shape with longer strokes.

Creating Darks Quickly

Through most of the book, I'll be reminding you to keep a light touch and let the value slowly build up with multiple layers of lightly applied pencil. But there are times when you have a flat area (with absolutely no gradation of value) that you simply need to fill with a dark value. In that case, there's no sense in slowly building a dark with sixteen layers of color. Using heavy pressure and darker value pencils, you can fill a dark area in three quick layers.

Creating Flat Darks
With a fairly sharp point (smoother coverage) and *heavy* pressure, fill an area with a dark value. Here I've used Scarlet Lake, but any darker pencil will do. Choose a second dark color, like the Indigo Blue I've used, and cover the first layer using heavy pressure and a sharp point. The last color here is black, again applied heavily and with a sharp point.

Impressed Line

Use a sharp instrument to indent the paper surface. When you cover the area with pencil, the impression made with the sharp object will not fill (it's an especially deep "valley") and will show up as white. You can use this technique for the little wisps of hair around the face that are often lit by sunlight. I also use this technique when drawing a beard or mustache that has a bit of gray or white in it by first impressing a few hairs I intend to remain lighter than the surrounding hair. And finally, when I can see there will be no place at the bottom of the portrait light enough in value for my signature to show up, I impress my signature first on the bare paper with a pen that has run out of ink, then let it show up as I work the dark pencils over it!

Burnishing

"Burnishing" is a fancy word for using so much pressure and so many layers that every hill and every valley in the paper surface is completely covered and the paper tooth (texture) is no longer visible. I tend not to do a lot of burnishing, but it can come in handy for certain surfaces, such as glass and metal, and for small highlights on dark hair or dark clothing. You have to be careful *not* to burnish when working on the face, since once the paper surface is all filled up, you're very limited on the number of additional layers you can apply.

Lifting

You never want to try to erase colored pencil. Erasing colored pencil with a traditional pencil eraser only rubs the pigment deeper into your paper surface. What you want to do instead is *lift* the pigment out of the hills and valleys of your paper surface. Kneaded erasers, "sticky stuff," invisible tape, masking tape, frisket film and clear contact paper will all work to lift colored pencil. The tapes and films are

 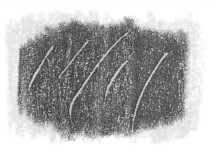

Impressed Line Technique
Use any sharp instrument to leave an indentation without tearing the paper (a few suggestions: a dried-out pen, a stylus, the *back* of a craft knife blade, a bobby pin with the protective cover removed). Over the top of the impression, layer colored pencil. It's better to use a dull pencil or the side of your pencil with this technique so you don't accidentally fill in the impression. In the right example, I covered the paper with a layer of Jasmine before impressing a few lines, then topped it with a coat of Dark Brown.

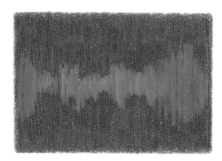

Burnishing
By using very heavy pressure, I've smoothed the surface of the paper with just two layers: a layer of Tuscan Red followed by a layer of Grape. On top of this burnished pencil, I've applied a layer of white in varying pressures. This technique is perfect for highly polished or reflective surfaces, such as glass, ceramics, satin and patent leather.

HINT

You never really get back to white when lifting colored pencil, whether you're using "sticky stuff," tape or an electric eraser. But there is a trick for small areas, if you really need to get back to white. Using a cotton swab dipped sparingly in household bleach, gently tap the surface of the paper. Within moments, you should see white again.

nice because you can see through them to be more specific about the area you're lifting. Just lay a piece of tape or film over the area you need to lift, apply a little pressure with your fingernail and then lift off the tape. For tiny areas, after laying down the tape, apply pressure with a pencil point to the specific area you need lifted, then lift the tape.

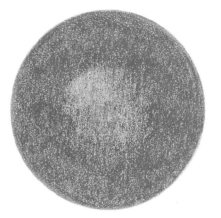

This was lifted with a kneaded eraser.

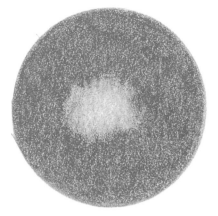

You can see how much more pencil the reusable adhesive ("sticky stuff") lifts. In this example, I've lifted several times, turning the blob of sticky stuff each time to use a clean surface to pick up the pencil. Don't be afraid of pressing down too hard with the blob; Stonehenge paper will take a lot of pressure.

Here I've laid clear tape across the surface, pressed on it with the side of my thumb, then carefully lifted the tape. (You don't want to remove the tape too quickly or you may pull up the paper surface.)

Layering to Build Rich Color

"Painting" with colored pencil is all about slowly building color by adding layer upon layer of pencil. I have a three-layer rule: No area should be covered with less than three layers of pencil and two different pigments. The average number of layers in any given area should be between six and ten, with some areas getting as many as fifteen! Why so many? Just one layer of just one hue of colored pencil looks very flat. Adding different hues, different values and different colors creates a richness and depth that one or two layers simply cannot. You'll see in later chapters how to build color slowly in layers to render surfaces such as clothing and skin; but to begin with, here is an example of how to create depth and model form simply by combining layers of different colors.

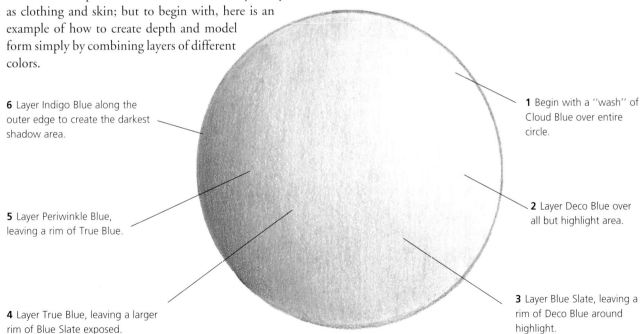

6 Layer Indigo Blue along the outer edge to create the darkest shadow area.

5 Layer Periwinkle Blue, leaving a rim of True Blue.

4 Layer True Blue, leaving a larger rim of Blue Slate exposed.

1 Begin with a "wash" of Cloud Blue over entire circle.

2 Layer Deco Blue over all but highlight area.

3 Layer Blue Slate, leaving a rim of Deco Blue around highlight.

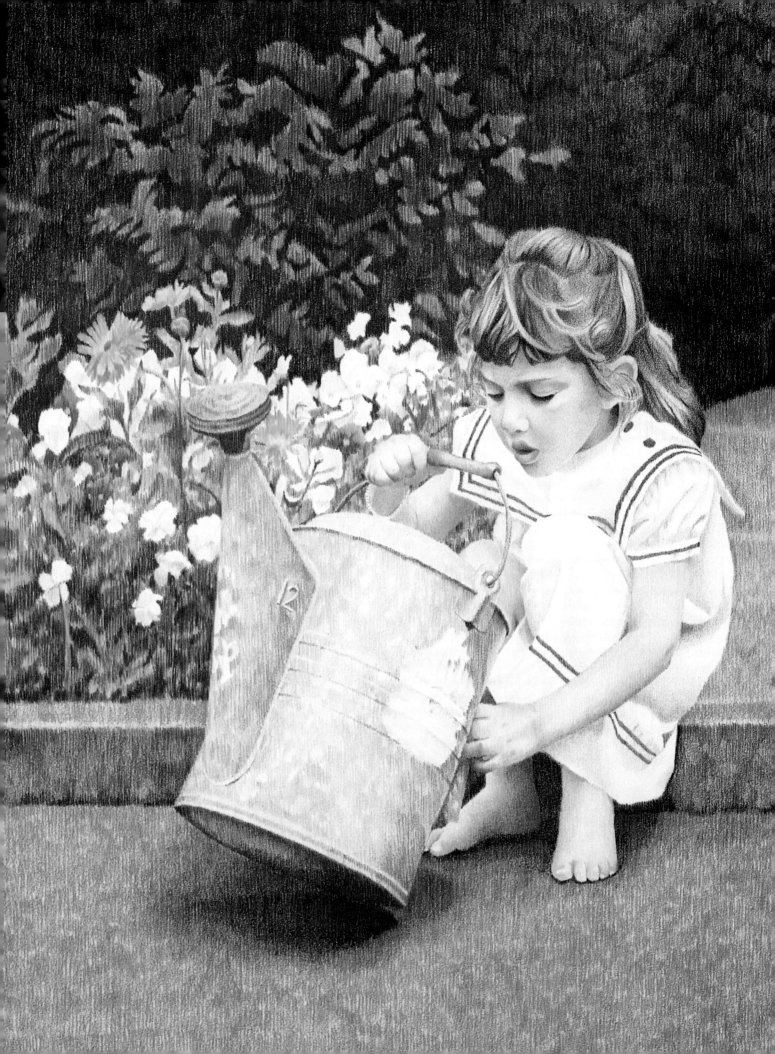

Composing a Portrait

The idea of "good composition" has always intimidated me. I don't have any formal art training; everything I know I've either learned by looking at art or by trial and error. I must be doing something right though, since I've heard many times (from those who should know) that my sense of composition is very good. So, rather than passing on too many rules, I'll just send a few tips your way about how I compose my work and try to help you *see* what looks best.

THE WATERER
26″ × 20″ (65cm × 50cm)
Collection of Marcia Weiss

Starting With Reference Photos

Good composition is a skill you develop over time. Initially, I think most artists focus on technique; but as technical skills improve, focusing on composition becomes easier. I have several older works that I would crop differently now, but at the time I was so intent on simply capturing the likeness that I wasn't able to see how the composition could improve. Composition is about balance: balancing a large shape with several small shapes, light areas with dark, straight lines with curved lines, flat areas with detail. But I actually don't think about balance or rules at all when choosing my compositions. So what *do* I do? I look. I look at lots and lots and lots of photos. I never take less than one hundred reference photos of my portrait subject. Once I get the photos back, I look through them very quickly, making a "possible" pile and a "no way" pile. I then go through the "possible" photos more slowly, cutting the choices to anywhere from three to ten shots. I'm looking for pleasing facial expressions, of course, but more than that I'm looking for the photo that "works." The one I'm drawn to, the one that feels right. It's all in the gut. Trust the gut!

Once I'm down to one to three choices, I start manipulating the image by framing the photo. Usually I just use the backs of four other photos laid over the four edges of my good photo. Then I start playing with the image, cropping a little here and a little there to see if the composition can be improved. Eventually, I come up with something I'm happy with.

It's important to note that when I look at my reference photos, I'm not *thinking* about any of the "rules" or elements of a good composition; it really is just comparison and purely a gut reaction. Only after the choice is

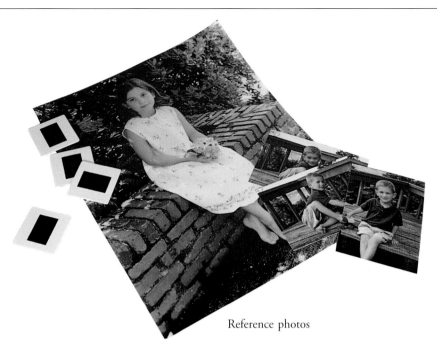

Reference photos

made am I really able to identify the elements that make it a pleasing composition.

Enlarging Photos

A word of warning: do not use a 3″ × 5″ (7.5cm × 12.5cm) photo as your only reference photograph. Any face in a photo that small is going to be *tiny*—far too small for you to successfully get a good likeness. Never, under any circumstance, would I consider working from anything less than an 8″ × 10″ (20cm × 25cm) enlargement. Usually I work from an 11″ × 14″ (27.5cm × 35cm). Colored pencil drawings take a long time; if you're willing to invest that much time in a drawing, help yourself out and have the photo enlarged. I strongly recommend this be a photo enlargement and not a color copy. Color copies, while cheap and quick, are also grainy, and the color quality is so unreliable. You get what you pay for!

You can get an "instant" photo enlargement these days at many photo labs. You don't even need a negative. I just take in my 4″ × 6″ (10cm × 15cm) photo, it's instantly scanned, I

HINT
I don't want to give the impression that I always work from just one reference photo. I often choose one shot for composition and another for facial expression. There are times when I work from a third or fourth photo for hand or foot placement or background changes. It's ideal *to have one photo to work from, but even with one hundred shots, it doesn't happen too often!*

see the enlarged image on a computer monitor and can make cropping choices, and like magic, I have an 8″ × 10″ (20cm × 25cm) in a matter of minutes. The cost is around ten dollars, so it is obviously much more expensive than a color copy, but the quality is so superior that I urge you to go that route over the cheaper one.

Getting It on Paper

Once you've chosen the composition and the photo(s) you'll be working from, your next step is to decide how to get your sketch onto your paper. There are so many ways to do this; I'm sure you'll find one that suits you perfectly.

DRAWING FREEHAND

If you are drawing freehand, here are a few tips. If your drawing is going to be appreciably larger than your photo, make your sketch roughly the same size as the image in the photo. It's much easier to mechanically enlarge your sketch than to try to enlarge while drawing. And if you don't already, try drawing on tracing paper. It's cheap and will take *tons* more erasing than any sketch paper ever could.

Once your drawing is complete, trace over your pencil lines with a fine-point pen, then enlarge it on a copy machine to the size you want. There are machines now that will enlarge up to 36 inches (90cm), so even with a small sketch you can work as large as you're willing!

TRANSFERRING

Now you need to transfer your sketch (or enlarged photocopy) onto your drawing paper. There are three ways I know of to do this. First, you can use transfer paper. It looks something like carbon paper and you just place it between the sketch and your drawing paper and lightly trace over your sketch lines. It helps to trace with a colored pencil so you'll know which lines you've already transferred. Be very careful not to use too much pressure while tracing or you'll accidentally impress the drawing paper. I'm not crazy about transfer paper. Some kinds are gummy and don't erase well.

Easy Transfer
The light coming through my sliding glass door allows me to see through my Stonehenge paper to the sketch below.

A second way is to use the side of an ordinary graphite pencil to cover the back of your sketch with lots of graphite. It works best if you cover it with two layers laid down in two different directions. Place this over your drawing paper and trace as explained previously. I like this method only a tiny bit better than transfer paper. It can be messy, but the graphite is at least easy to erase.

My choice for transferring is a back-lighting technique, similar to the way a lightbox works. I've found my sliding glass door works beautifully as a "lightbox"! I use "sticky stuff" to attach my sketch to the door and to stick my drawing paper to the sketch. I can easily see right through the Stonehenge drawing paper, so with a sharp graphite pencil, I very lightly trace the outline of my sketch onto the Stonehenge and I'm good to go! For years, I only transferred during the day, but I've discovered that by turning on the outside patio light and turning off the indoor lights, I can transfer after dark.

DRAWING WITH GRIDS

If you're not too confident about your drafting skills, I highly recommend drawing with grids. Drawing with the aid of a grid is helpful in improving your drafting skills since it teaches you to use reference points (the lines of the grid), and drawing is almost *completely* about referencing. Following is the setup I use when drawing with grids. Although the initial preparation takes a little time, I definitely think it's worth the effort.

1 Using a fine-tip permanent marker, draw a grid of 2-inch (5cm) squares on a very large piece of white posterboard. Attach the posterboard to the top of your drawing table.

2 Using a fine-point pen, make grids on 9″ × 12″ (22.5cm × 30cm) white paper in four different sizes: ¼-inch, ½-inch, ¾-inch and 1-inch (.6cm, 1.25cm, 1.9cm, 2.5cm) squares. Have the grids photocopied onto acetate. (You could use permanent marker right on acetate to make your own grids, but I find that the marker wears off more quickly than if it's photocopied.)

3 When you're ready to draw, place a large piece of tracing paper over your posterboard grid. You can see your grid lines through the tracing paper, and this will be your drawing surface.

4 Lay one of the acetate grids over your reference photo. If you want your drawing to be twice as large as your photo, use the 1-inch (2.5cm) grid. If you want it four times larger, use the ½-inch (1.25cm) grid, etc.

5 Now you're ready to draw. If the hand in your photo is six squares down and three squares over on the acetate grid, count six squares down and three squares over on the grid under your tracing paper and that is where you will draw the hand.

Here I've placed a 1-inch (2.5cm) acetate grid over my 11″ × 14″ (27.5cm × 35cm) photograph.

To make the drawing 100 percent larger than the photo, I've placed my drawing surface (tracing paper) over a 2-inch (5cm) grid attached to my drawing table. Since the bottom of the ear on my reference photo fell in the second square over and the eighth square down, I counted two over and eight down on my tracing paper and began the ear in that square.

PROJECTING

If you already feel confident about your drawing skills, or if you don't want to take the time to learn, there's always the option of projecting an image onto paper. Many, many artists use projectors, and I suppose the debate about whether or not this is cheating will rage on forever. My personal opinion is that it's totally up to the artist. A highly skilled renderer may choose to use a projector to save time. Those who can't draw a lick won't really be helped much, since a well-traced sketch can turn into a nightmare painting in the wrong hands!

There are opaque projectors and all sorts of machines out there to help you project a photograph onto paper. I don't care for any of them. My choice for projecting is a 35mm slide and a slide projector. The image is brighter and much sharper than with even the best opaque projectors. Just put some sticky stuff on the back of your drawing paper, attach it to a wall, turn on the slide projector and trace away!

Learning to See Good Compositions

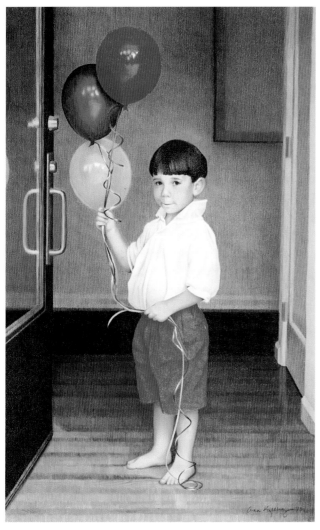

MICHAEL
16″ × 20″ (40cm × 50cm)
Collection of Greg and Amy Lowes

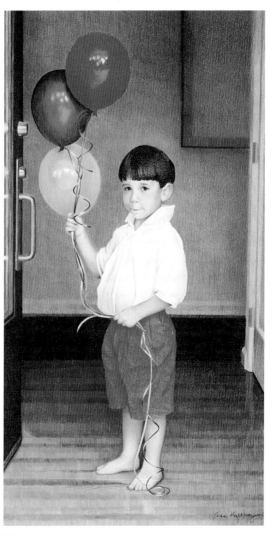

Right
Little Michael is very close to the center of this piece, but there's actually a little more space to his left—the same way he's facing. You generally want to have more space in the direction the subject is facing, rather than the other way around. There's a nice path here that leads from the green door into the picture, to the balloons, to Michael's arm, to his figure and face. The frame of the picture on the back wall also seems to point to Michael's face, and the neutral, flat background helps to pop out his bright white shirt and glowing face. Finally, Michael isn't crowded; there's plenty of room on both sides and above and below him.

Wrong
In this crop, the narrow sections of door on either side of the painting are distracting. Very narrow spaces near the edges of your painting draw your eye *out* instead of *in* to the drawing; you want to avoid them whenever possible.

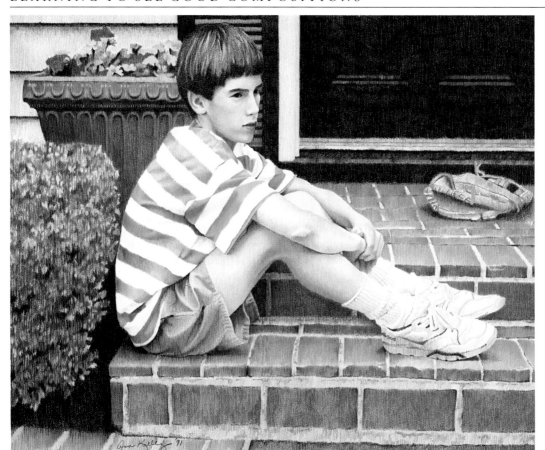

LONG AFTERNOON
15″×19″
(37.5cm×47.5cm)

Right

The door, window shutter, flowerpot and bush seem to form a frame around this young man, leading your eye to his face. The dark shutter is a good backdrop for the lighter, warm skin tones of his face. The large, flat, dark shape of the door balances the "activity" of his shirt and the box elder bush, as does the baseball glove.

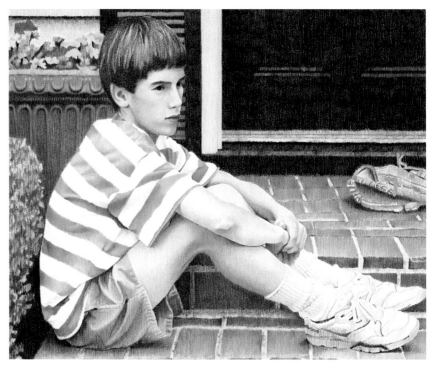

Wrong

The figure is far too crowded in this crop. Be sure to leave enough space on all four sides of your portrait subject. The objects that seemed to frame him in the previous shot are now too small and distracting.

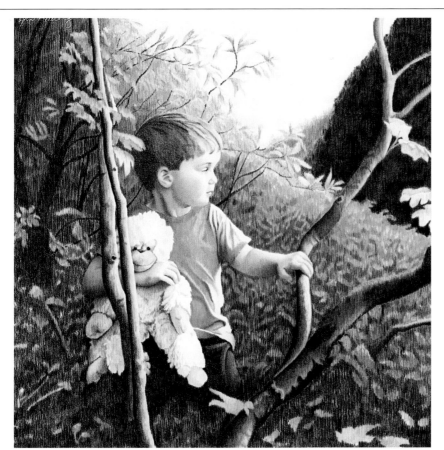

Right

I broke a composition "rule" with this one: no square pictures. Nonetheless, this has always been one of my favorites! So what makes this work in spite of the broken rule? For one thing, all of the lines of the hills and tree branches run diagonally in this piece. The boy and his monkey are the only things that are completely vertical, which helps to bring your attention to him. Also, there's a triangle in the center formed by the nearer hill and the two main tree limbs. The boy "lives" within that triangle, just a little left of center, which breaks up the "squareness" of the piece. And last, the loose and busy quality to the background and foreground really allow his clear, smooth little profile to be the calm at the center of the "storm."

BEHIND THE HOUSE
15″ × 15″ (37.5cm × 37.5cm)
Collection of the artist

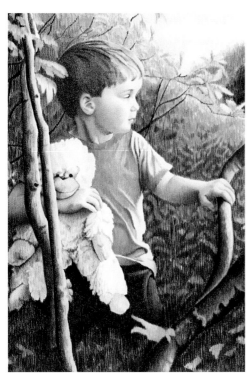

Wrong

Another bad crop. It's more intimate, but without the strong line of the far hill for balance, the tree limbs become a distraction; they're too strong and too central to the composition now, and instead of framing, they seem in the way.

NOT EVERYTHING
IS BLACK AND
WHITE
18″ × 26″
(45cm × 65cm)
Collection of the artist

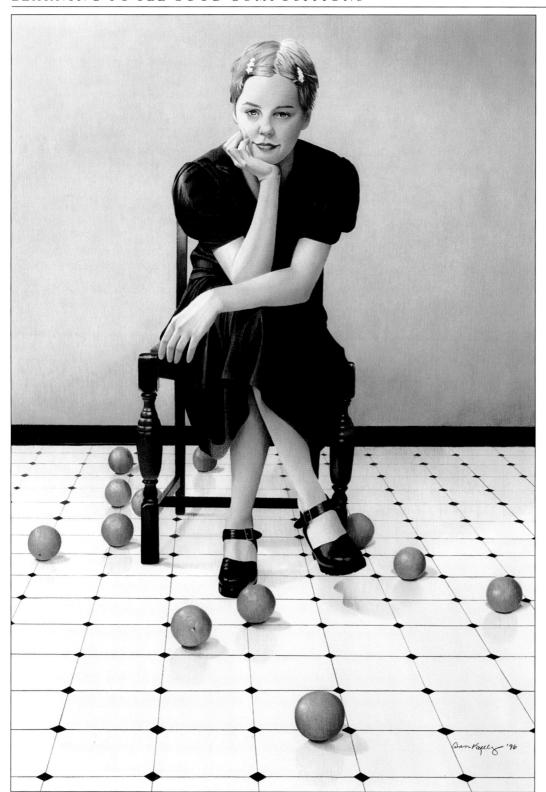

Right

Stephanie was a friend of my daughter, and I wanted to capture that "not yet woman, not still child" quality I saw in her fourteen-year-old face, while also playing a little with color and form. I chose to drop oranges on the floor before taking the photos because I thought they would make an interesting contrast to the complementary blue of the wall. I didn't "place" the oranges, I just let them fall where they would. I only had to add one orange to make the composition feel right—the one closest to the bottom of the painting. The roundness of the oranges also breaks up the very angular lines of the floor and Stephanie's arms and legs.

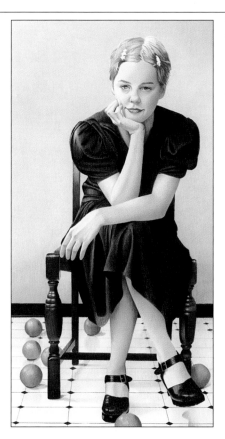

Wrong
This would be a very bad crop for this piece. The three oranges on the left line up too neatly and follow the line of the chair too closely, which is awkward when you don't have other oranges to break up that line. Stephanie is also too far to the right here—I keep wanting to push her chair to the left!

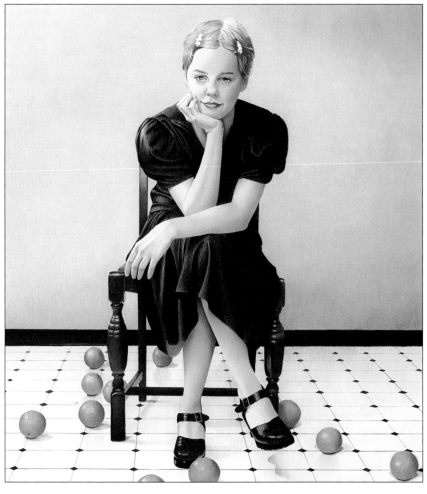

Better
This is a better crop, but the drama is reduced when you take away the "lead-in" of the floor. This works, but there's not nearly as much impact as in the first example.

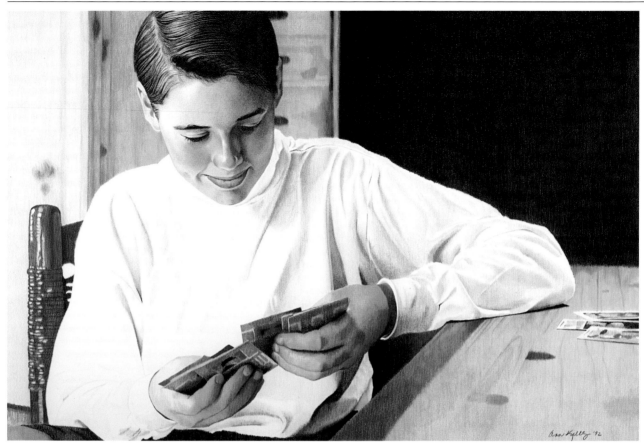

This is a more contemporary composition due to the cropped head and large, unbroken planes. The repeated wood grain shapes on the table and behind Chris's head help to unify the piece. The five flat planes of color help pull your eye to the only real detail in the whole painting—his face. Also, the large black background in the upper-right corner provides a nice balance for the small, relatively busy chairback in the opposite corner.

CHRIS
18″ × 27″ (45cm × 67.5cm)
Collection of Steve and Barb Spence

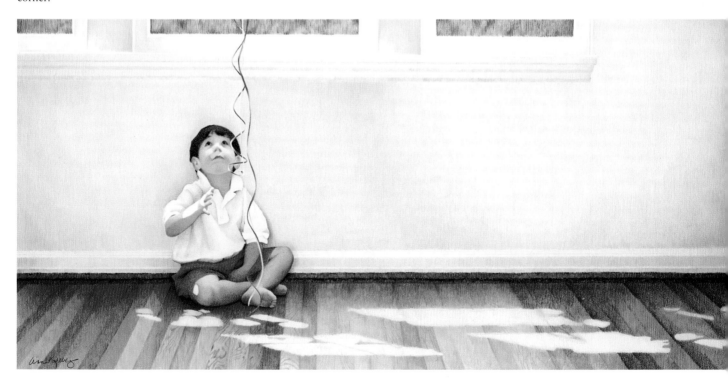

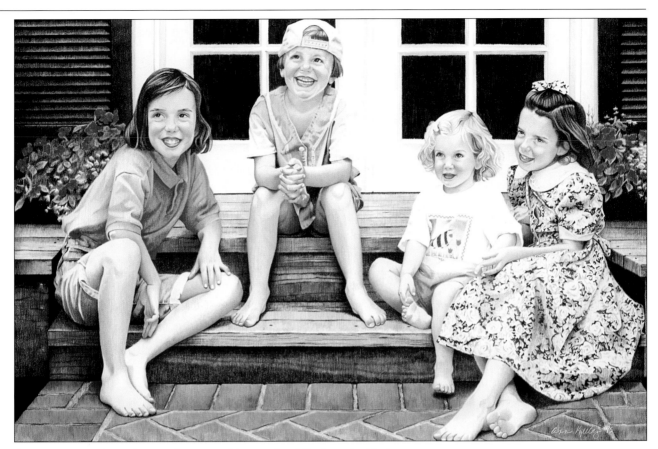

Composing portraits with more than one subject can be difficult, and with three or more, it's even harder. Here I've placed the children in a sort of arc, with the larger form of the two children on the right balanced by the separated forms of the two on the left. By placing one child on a different plane, I broke up the static "all-lined-up" effect that may have occurred had I placed them all on the same step.

THE LILLEY CHILDREN
20″×25″ (50cm×62.5cm)
Collection of Charles and Denise Lilley

◄ *Helium* has two subjects: little Michael (the balloons got away from him this time!) and the light hitting the floor. This is another more contemporary composition with its narrow, horizontal format full of lots of relatively flat space. The large, horizontal forms and nearly empty space insist you pay attention to Michael's small, round details.

HELIUM
23″×40″ (57.5cm×100cm)
Collection of Timothy A. Liszt

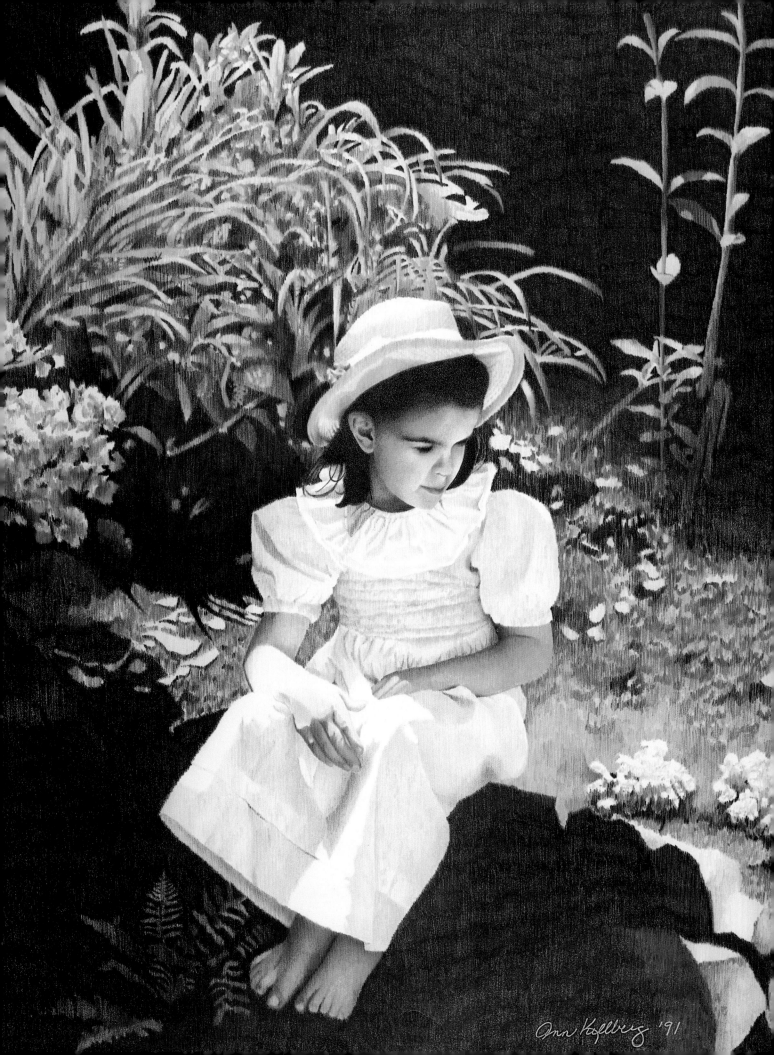

Ann Kullberg '91

Seeing the Light

My artist friend Chris insists that it's not people I paint, it's light. I suppose to a certain extent he's right. I do dearly love the play of light as it falls on absolutely anything. And when a piece I'm working on reaches the point of high contrast between light and shadow, that is when the painting starts to "sing" for me. It wasn't always like that. My early work was very low in contrast and didn't hold the dazzle of light at all. This was partially because I was using the "Brillo pad" technique throughout and partially because I lacked guts! I've found it takes courage to really bear down on those points and get that colored pencil good and dark; but without darks you really can't show light!

KIRSTEN
21″×27″ (52.5cm×67.5cm)
Collection of Simon and Lisa Acheson

My Journey "Toward the Light"

I took me nearly three years of working in colored pencil before I was able to really use light in my work. It was a long process that involved first learning to build darks, then learning to create contrast and, finally, really seeing the light and accentuating it with deep contrast.

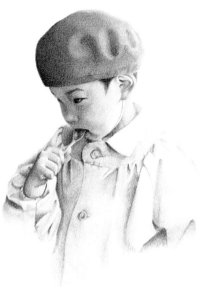

Stage One: 1988

This little vignette is an example of what I call an anemic colored pencil drawing. I drew this about a year after I'd begun working in colored pencil, and although I think the little boy is adorable and I did a few things right, it could still use quite a bit of help. The piece now looks "airy" to me, lacking in contrast, "punch" and drama. The entire drawing was done by scumbling—my "Brillo pad" technique. With this slow, precise, almost painstaking method, it does seem more difficult to achieve really rich darks. In this piece, I have a couple of spots of dark values in his eyes and a bit of his hair, but most of the drawing consists of medium values. Consequently, it's fairly flat. Also, although this little drawing looks good up close, from across the room, an anemic drawing loses everything because you can hardly see it! Now, nine years later, I would consider this piece less than half completed.

Stage Two: Early 1989

By this stage, I had dared to go a little darker and push a little harder with my pencils. The paper surface is definitely less visible than in earlier work, but there's still no deep contrast. Most of the values are still in the light to medium ranges. There are some shadows, but the essence of light certainly doesn't jump out at you.

THE VERANDAH
22½″ × 13½″ (56.5cm × 34cm)
Collection of the Reverend Albert and Madeline Carow

Stage Three: Late 1989

Three Boys was one of the first pieces I completed after developing my vertical line technique. At this early stage, I placed the strokes farther apart and covered the paper with fewer layers than I do now. That's why so much of the paper surface is visible. (I scumbled the boys' faces.) Although the faces do seem to glow here, it is due more to the contrast between the tight, warm skin tones and the looser, dull background than to high value contrast.

THREE BOYS
27″ × 14½″ (67.5cm × 36.5cm)
Collection of Jerilyn Domagala

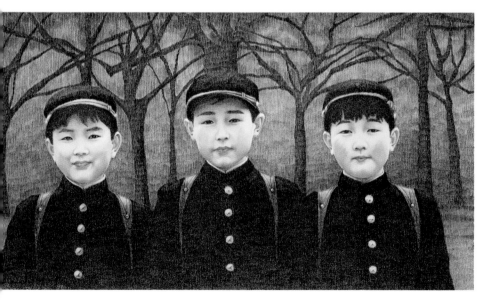

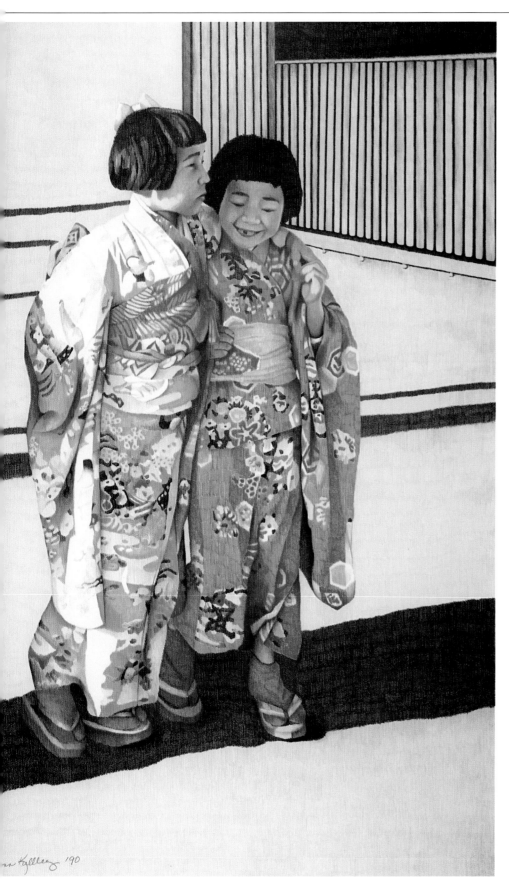

Stage Four: 1991

Within a year of developing the vertical line, I learned to use the technique to create the full spectrum of values from very light to very dark. In *Best Friends*, the lightest values are actually just the white of the raw, uncovered paper. The medium and dark values also appear denser than in *Three Boys* because by this point I was using more layers, more pressure and applying my strokes closer together. And by this stage, I'd finally learned that to really capture light, you must have very light areas right next to very dark areas.

BEST FRIENDS
32″ × 20″ (80cm × 50cm)
Collection of Phil and Maryl Carow

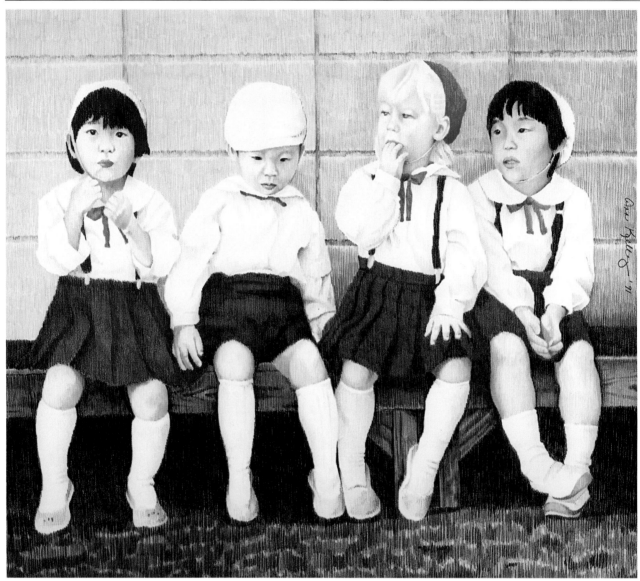

KAREN'S KINDERGARTEN
18″ × 15½″ (45cm × 39cm)
Collection of Simon and Lisa Acheson

Painting Strong Light

Having said that to capture light you must have high contrast, I now have to say it takes more than just having the full value range on your paper. There's no question I have plenty of contrast in *Karen's Kindergarten*. The children's bright white socks and shirts are right next to very dark areas. And there's no lack of "punch" to this work; with all the darks and lights, this piece isn't "lost" from a few feet away. But there *is* a lack of strong light. The light is soft, and you can tell the reference photo was taken on an overcast day.

So what is it we see that tells us this is a cloudy day? For one thing, shadows in soft light are only a shade or two darker than the nonshadowed areas—compare the shadows cast by the collars of the shirts with the shirts themselves. Now look at the girl on the left in *Best Friends* on page 33. Notice the shadow her hair casts onto the back of her neck. Here there is a great difference in value between that shadow and the surrounding skin. Looking back at *Karen's Kindergarten*, you see that the shadows on the children's faces are very soft, with no clean, sharp edges; they just sort of fade away. In *Best Friends* you can see the sharp lines of both the shadow on the girl's neck and the shadowed areas of her kimono.

That's really all there is to capturing strong, beautiful light. It's as easy as creating light lights, dark darks, shadows several values darker than the surrounding area and crisp, clean edges.

Put as simply as possible, to show

strong, direct light in any one area you need four elements:
- sharp, clean-edged shadows
- a very light highlight
- a very dark shadow
- a medium value that shows what that area looks like neither in shadow nor direct light

Little five-year-old Kelly, below, is def-initely awash in sunlight, and the deeply shadowed background really helps to show off that lovely light. Here you can see that all four elements of capturing light are present throughout the portrait.

By now, you should have no prob-lem finding the elements here that really speak of light. Try it! One last tip: If I'd done *First Cousins*, page 39, in exactly the same way but with a lighter colored background, the chil-dren would still look as if they were sitting in sunlight. The very dark green backdrop, however, really accentuates the light, warm tones of the children and adds the punch that makes this painting a dramatic show of light.

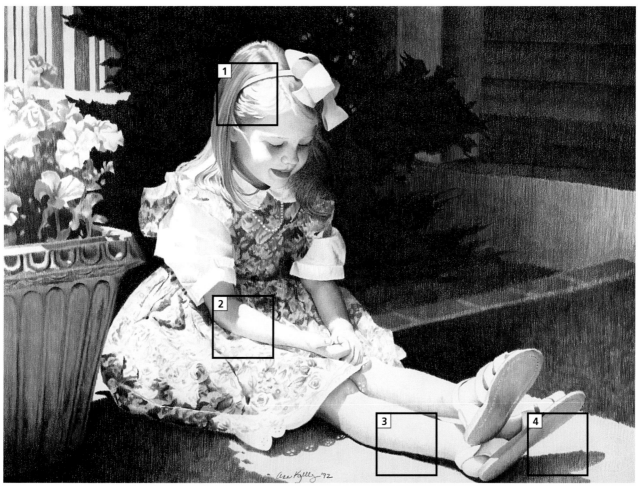

1 In one tiny spot on Kelly's hair, you can find the entire range of values from the very dark cast shadow to the white highlights. The edges of the highlights are very sharp and clean.

2 Though not as dark a shadow as on Kelly's hair, here too I have a clean edge, dark shadows, medium values and white highlights.

3 The closer an object is to the surface it casts a shadow on, the darker the shadow. Kelly's leg is very close to the patio here, so the cast shadow is very dark and dense.

4 The bottom of her sandal is very close to the ground, so the corresponding shadow is very dark. The top of her foot is farther away from the patio, so the shadow becomes lighter and less dense.

KELLY . . . SUNWASHED
28″×32″ (70cm×80cm)
Collection of Patrick and Mary Brophy

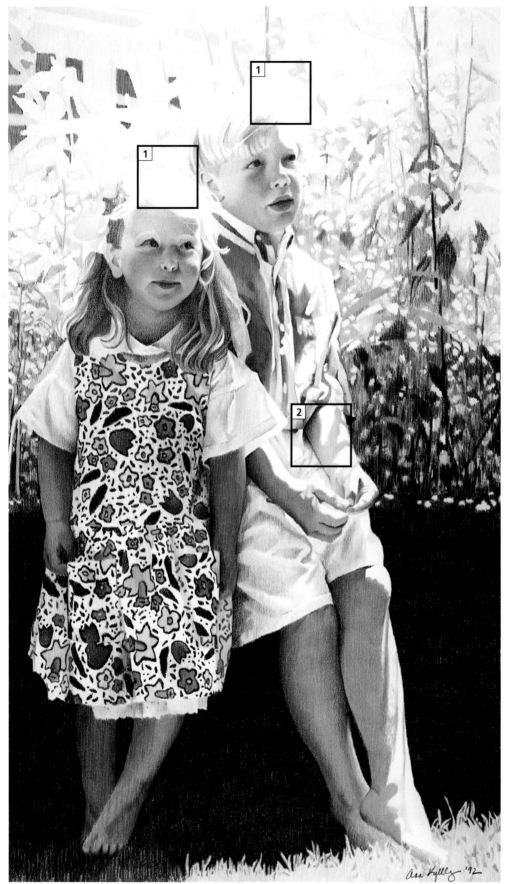

1 As I often do, here I've let the paper "do the talking," simply using the white of the Stonehenge to act as the bright highlight on the top of the children's heads.

2 This area on Brian's arm shows the highlight, as does how dark I've rendered the inside shadow compared to the rest of his skin tones.

If this portrait doesn't speak to you of warm, sunny afternoons, I don't know what will! All of the clues that let the eye read strong light are here: The lights are white, the darks are rich and dense, the shadowed areas are many degrees darker in value and the shadow edges are sharp and well defined.

BRIAN AND KATE
27½" × 16" (69cm × 40cm)
Collection of Stephen and Kathy Kelly

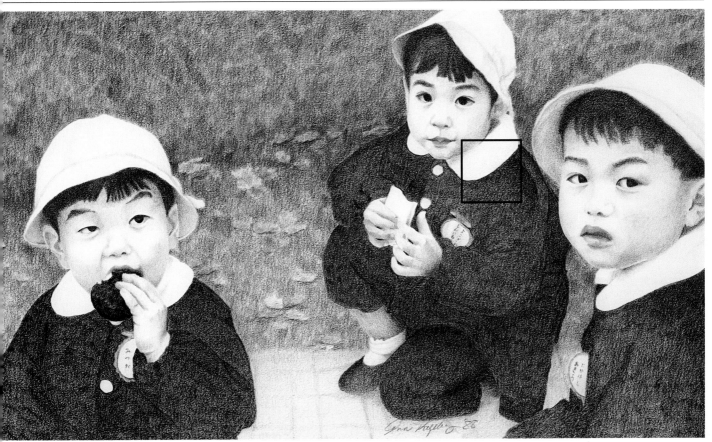

One more time: It takes more than dark next to white to create the look of light. The reason this doesn't read as strong light is that the white area here is light because it's a white collar (*not* because it's in sunlight) and the dark area is dark because it's a black shirt (*not* because it's in shadow). The dark shirt would have to have nearly white highlights within it to look like it's in direct light. The white collar would have to have very dark shadows within it to appear brightly lit. As it is, the light looks flat and diffused.

KINDERGARTEN BOYS
19½″ × 11″ (49cm × 27.5cm)
Collection of Joe and Sharon Foy

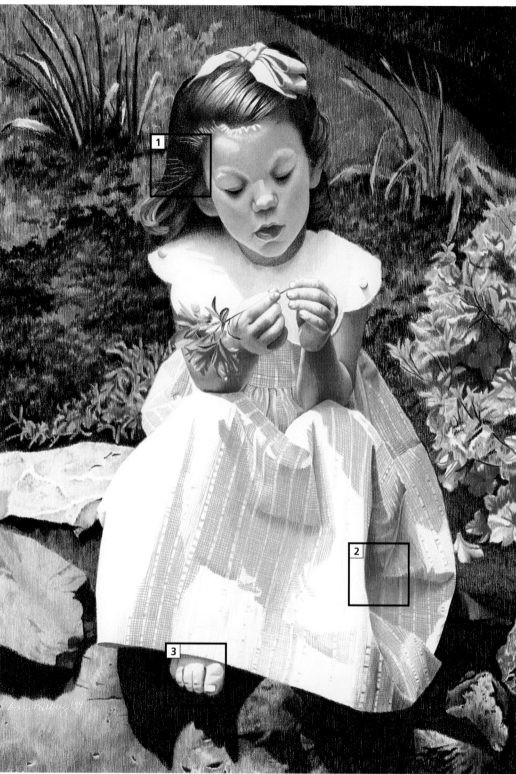

A few days after I delivered this portrait of four-year-old Mady, her mother called. While looking at her own portrait that morning, Mady had said, "That's me—forever." It was one of the most touching things I'd heard from a "client" and brought tears to my eyes. Out of the mouths of babes. . . .

MADY
21″×15″
(52.5cm×37.5cm)
Collection of Jim and Kelly Johnson

1 These tiny golden wisps of sunlit hair really help to bring out the light in this portrait. The finer wisps were first impressed with one end of an opened paper clip before I began rendering her hair.

2 If I'd left the shadow two or three shades lighter in value, it still would have easily "read" as shadow. Darkening it as much as I did, however, intensified the sunlit effect and added a touch of drama.

3 With the backdrop of the deep shadow, Mady's highlighted little foot poking out from her dress really clinches the sunny mood of this portrait. The very dark line between her big toe and the others also helps to accent the light.

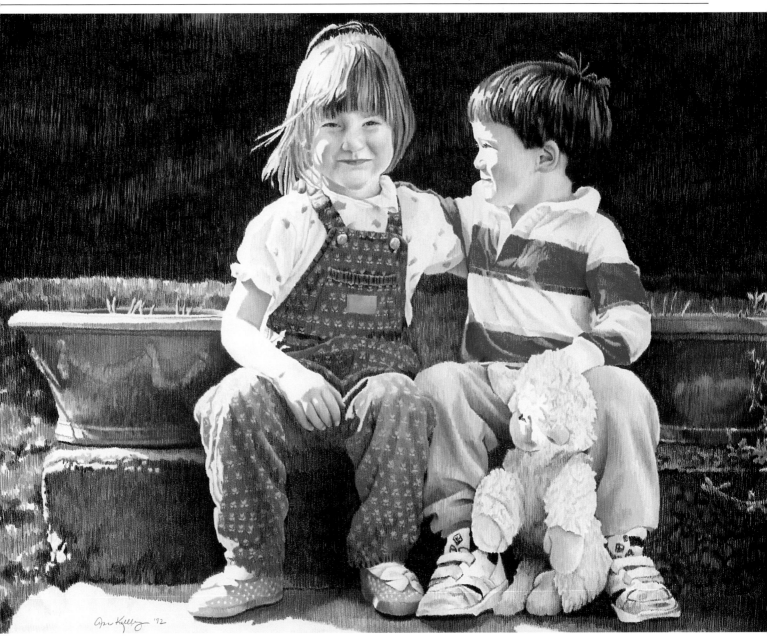

FIRST COUSINS
30″×21½″ (75cm×54cm)
Collection of Michael and Tammy Connors

HINT

Now that you've "seen the light," don't think for a minute that dazzling light is essential *to an outstanding portrait. It's not. In fact, since many people squint in bright sunlight, it can be a minus rather than a plus. What often works best is to have your subject's back to the light, as in* Brian and Kate *on page 36. With that positioning, you can still get much of the drama of sunlight without losing open, relaxed eyes and features.*

Ann Kullberg '95

Creating Believable Skin Tones

Skin can be scary! Painting believable, touchable, breathing skin tones may be one of the most intimidating tasks for an artist. But it doesn't have to be so frightening. Painting believable flesh tones is truly no different from rendering believable fabrics, flower petals or clouds. The main difference is none of us has spent a single day without seeing skin, and because it is so common, we tend to *stop* seeing it. By slowing down, taking a careful look and keeping a few key points in mind, you can be well on your way to glowing, lifelike skin tones.

PARKER
16″ × 23″ (40cm × 57.5cm)
Collection of George and Wanda Osgood

Palette Guide

Over the years, I have developed a palette guide for building skin tones. This is not a *formula*; it is only a guide! Skin comes in too many shades to rely on any one predetermined set of colors. This color guide can, however, provide a foundation for skin tones of all ranges. The following shows the twenty-three colors in the skin tone color guide, arranged by hue.

As I work on a face, I constantly keep in mind the three main color groups: yellow, orange and pink. As I render, I move from one group to the next, trying to keep a balance between the three groups. Except when working on black skin, I use the brown group only to blend with the other three groups to darken their values. Using too much brown results in skin that looks in need of a good scrubbing!

HINT
Orange is a very difficult color to correct. If you've gone too orange, there's not a lot you can do about it. Sometimes adding the greyer tones will help a little; try Rosy Beige or Clay Rose. My advice: Go easy on the orange group, and always proceed with caution!

YELLOW SKIN TONES

Cream

Jasmine

Yellow Ochre

Goldenrod

ORANGE SKIN TONES

Beige

Peach

Mineral Orange

Pumpkin Orange

Burnt Ochre

Terra Cotta

PINK SKIN TONES

Light Peach

Deco Pink

Pink Rose

Rosy Beige

Blush Pink

Clay Rose

Pink

Henna

Tuscan Red

BROWN SKIN TONES

Light Umber

Dark Brown

Dark Umber

Black

Arranging Your Colors by Value

You now have the right colors, but what do you do with them? Although I do mentally think of my palette in groups of yellows, oranges and pinks, I also organize them by value. I've arranged them here in six groups of increasing value, from the lightest group of Cream and Light Peach, to the darkest group, which includes black. Thinking in terms of value is vital to the technique of slowly building up flesh tones, layer upon layer. The next sections will show you how to use these value groups to create smooth transitions for perfectly blended skin tones. (It's important to note that the arrangement of colors within each value group is completely arbitrary and is not based on value.)

VALUE GROUP 1 VALUE GROUP 2

Cream	Light Peach	Jasmine	Deco Pink	Pink Rose	Beige

VALUE GROUP 3

Yellow Ochre	Peach	Mineral Orange	Blush Pink	Rosy Beige

VALUE GROUP 4

Goldenrod	Clay Rose	Pink	Light Umber	Pumpkin Orange	Burnt Ochre

VALUE GROUP 5 VALUE GROUP 6

Dark Brown	Terra Cotta	Henna	Dark Umber	Tuscan Red	Black

Applying the "Wash"

You now have the basic colors you'll need for your palette, arranged by value. What's next? You want to start with what I call a "wash." This doesn't involve anything wet; it's still dry colored pencil. I call it a wash because it is a light tonal application of color with no modeling or variation in value. It gets rid of all that white paper and provides a base for building the rest of your skin tones. (The following demonstrations are for Caucasian skin. Asian and black skin tones are covered on pages 53–57.)

As with everything I paint, I begin skin tones with the lightest color and value I see; Cream and Light Peach are the lightest colors from the skin tone palette, so I start with those two pencils. I first lay down a wash with Cream, followed by a wash of Light Peach. These are applied with a very sharp point and a very light, consistent touch. Applying an even wash as a base is key to achieving smooth, flawless skin. Practicing even color application with consistent pressure will help tremendously when you set out to render the skin tones on a face.

Before we go any further, let me stress how important it is to keep these washes light. Your paper's surface is full of little hills and valleys—the "tooth" of the paper. Even with a wonderful paper like Stonehenge, there's a limit to the amount of pressure and number of layers the tooth will hold. If you begin with too much pressure, you'll flatten the "hills" and fill the "valleys" very quickly, leaving too little tooth for all the subsequent layers. Eventually, the paper will give out, and with no tooth to hang onto, the pencil will just slide over the previous layers, making no mark.

HINT

Turn your pencil and keep turning it every few strokes to keep a sharp point. On skin more than anywhere else, it's crucial to keep your touch consistent. If you work several strokes without turning your pencil, you wear the point down to a large flat surface that lays down color in a much different manner than a sharp point.

Step 1: Applying the Washes
These two layers of Cream and Light Peach may be hard to see. That's good! This shows how very light your first two washes should be. Applied with a super sharp point and a light, even touch, the vertical strokes are so close together they nearly merge, creating a soft, even, "airbrushed" look that forms the foundation for the rest of your skin tones.

HINT

When arranging colors by value, keep in mind that all the colors shown at left were applied with consistent medium pressure. If you applied a very light color like Deco Pink with very heavy pressure, you could actually make it a darker value than a very lightly applied black pencil.

"Introducing" New Colors

Now it's time to start building by "introducing" a new layer of color on top of your washes. Since the "introduction" of color is the most crucial step to achieving smooth, flawless skin, I have provided several examples. To blend each new color layer onto existing layers, you will want to start with a very sharp point and an *extremely* light touch, then gradually increase your pressure. Those first few light, feathery strokes may seem unimportant (you may not even be able to see them), but they make the difference between a well-blended introduction and a poor, choppy one.

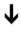

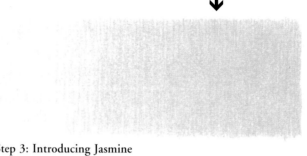

Step 2: Introducing Deco Pink
Here I've introduced a layer of Deco Pink to the first two washes from page 45. I began by applying a few widely separated strokes with *very* light pressure, a little to the left of the arrow. As I moved toward the right, I gently increased the pressure and brought my strokes closer together. The goal is to be able to see a new color has been added, without being able to see precisely where it began.

Step 3: Introducing Jasmine
Now I've added a second color to the washes. I began slightly to the right of the area where Deco Pink was established. Then using gradually increasing pressure and pulling my strokes closer together, I blended Jasmine on top of the Deco Pink layer. You know the Jasmine is there, but if it's done right, you can't see where it started! Once it'd been introduced, I continued the Jasmine layer to the far right end of the bar.

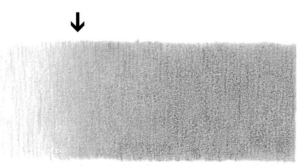

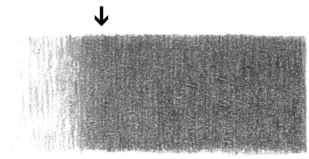

In an attempt to show the blending process more clearly, I've here introduced a layer of Crimson Red over the washes of Cream and Light Peach. My pressure gradually increased to a medium-light touch as I moved to the right.

Here I've used Ultramarine to emphasize both the difference in pressure and the distance between strokes. Once the color was successfully introduced, I kept an even, medium-light pressure through the rest of the color bar.

Making a Skin Tone Bar

OK, you're ready for the fun part: creating beautiful skin tones! By gradually introducing new color layers to your washes, you can build skin tones of any hue. A very useful tool to have nearby as you work on portraits is what I call a "skin tone bar." This is a value scale of flesh tones you create by introducing progressively darker values to the washes.

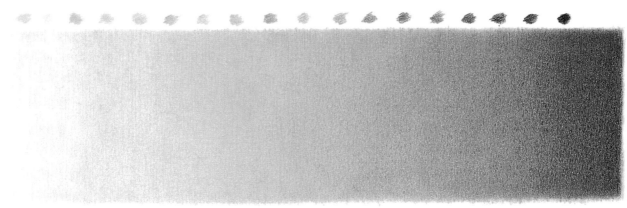

Step 4: Building by Blending

This skin tone bar was created by introducing twenty-one colors over the first two Cream and Light Peach washes. Somewhere along this scale, you will find nearly every shade of skin tone you will ever need.

1 Start by covering a horizontal rectangle (about 2″ × 8″ [5cm × 20cm] is a good size) with light washes of first Cream, then Light Peach.

2 Beginning slightly to the right of the left end, put a small swatch of Deco Pink above the bar.

3 A bit to the right of that, put a small swatch of Jasmine, followed by one of Pink Rose and one of Beige. Continue down the list of skin tones (as listed by value) putting small swatches of each at even intervals, ending with black.

4 Now, over the first two washes, introduce Deco Pink by starting a little to the left of your Deco Pink swatch with a few widely spaced, *very* lightly applied strokes.

5 As you move to the right, bring your strokes closer together and gradually increase your pressure. By the time you are directly under the swatch, your strokes should be quite close and applied with light to medium pressure.

6 Now carry the Deco Pink at that pressure level *all the way through* to the right end of the bar. Keep introducing each new color in the same manner.

7 When the bar is finished, the far left portion will be covered by just two layers: Cream and Light Peach. The far right portion will be layered with all twenty colors, ending with black. You don't have to increase your pressure as you move to the right. The multiple layers and darker colors will automatically darken the value as you work toward the end of the bar.

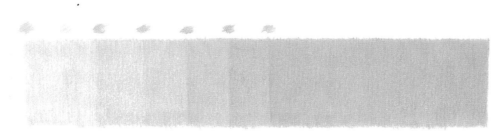

Example of Poor Color Introduction

Here's what you don't want! If you can see precisely where a new color layer was added, you haven't begun your color introduction with a light enough touch. But don't panic, this is easy to correct by simply going to the left of each new color introduction and adding a few very light strokes until you no longer see any definite line. Don't forget to start with a sharp pencil and turn it often!

Building Skin Tones Step by Step

Building skin tones on an arm or leg is really no different than building a skin tone bar. You begin with washes, then slowly introduce light layers of color in increasing values. These two pictures show how I built the skin tones on these little arms.

You'll notice that although five of the six value groups are represented in this demonstration, I didn't use all of the colors in each group. (I left out Beige, Goldenrod, Light Umber, Pink Rose and Pumpkin Orange.) When building by value, as you darken the skin, each group needs to be represented, but each color within each group does not. Let your reference photo guide you in choosing which colors to include and which ones to leave out. Also, once you've used a certain color, say Peach, then moved up to darker values, say Light Umber, don't think you can't go back down to Peach. I often reapply colors as needed and find that going back a value or two can help blend and even out skin tones.

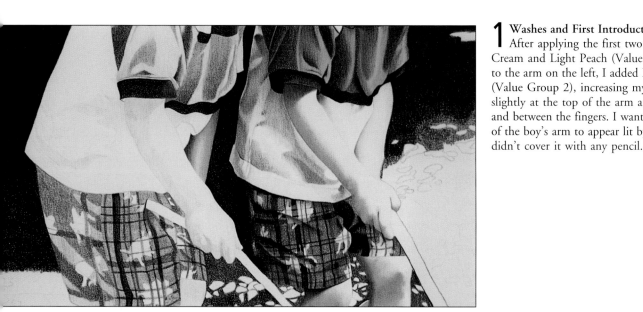

1 Washes and First Introduction
After applying the first two washes of Cream and Light Peach (Value Group 1) to the arm on the left, I added Deco Pink (Value Group 2), increasing my pressure slightly at the top of the arm and elbow and between the fingers. I wanted the top of the boy's arm to appear lit by sun, so I didn't cover it with any pencil.

2 Building the Values
Over the first three layers, I've lightly applied Jasmine (Value Group 2) and Yellow Ochre (Value Group 3), again increasing my pressure only slightly between the boy's fingers.

The right boy's arm had the same first layers as the arm on the left, but over the previous five colors, I've layered Mineral Orange, Blush Pink and Rosy Beige (Value Group 3) over his entire arm and hand, thus completing his forearm.

Next, I layered Clay Rose (Value Group 4) around his wrist bone, then darkened the lines between his fingers with Peach (Value Group 3), then Burnt Ochre (Value Group 4), and finally a light layer of Henna (Value Group 5).

Finally, I introduced Burnt Ochre to the cast shadow on his upper arm, followed by Pink, then Clay Rose (Value Group 4). I finished the upper arm by introducing Terra Cotta, then Dark Brown (Value Group 5).

Using a Value Viewer

I've noticed with students new to both colored pencil and portraiture that it sometimes seems difficult for them to trust how dark or how light certain skin tones appear in their reference photos. The result is often flat skin tones with little difference in value. It takes a bit of practice, and sometimes courage, to be able to accept what you see and represent it in your painting.

There is a tool that can really help with this problem. I call it a "value viewer" and have found it to be an invaluable aid through the years. A value viewer is simply a piece of white paper with a hole through the middle. Mine was made with a piece of laminated card stock and a hole punch. When you place the value viewer over your reference photo, the opening surrounded by the large white space instantly isolates that small area, allowing you to see clearly not only the value, but also the exact colors found there.

It is such a simple tool, but does the trick every time. Often, when I'm not sure what hues are present in a particular area (usually because my mind is overriding what my eyes are seeing), the value viewer immediately clears up the confusion. If you have two value viewers, you can place one over your photograph and one over your drawing to see an isolated comparison of the values or hues.

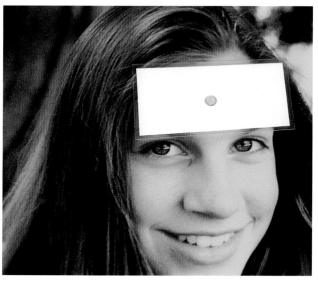

The value viewer placed over this subject's forehead shows how very light her skin tones are in this area—I would only go as far as Value Group 2 here.

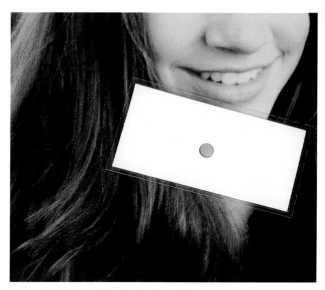

Her neck, shadowed by her head and hair, is several shades darker. I would probably go as far as Value Group 4 here.

If you think the area isolated here is hair, you're wrong! These are still skin tones, darkened by the cast shadow from her hair. On this spot, I could build right up to Value Group 6 without worrying about going too dark.

Compare this spot with the dark forehead isolation at left. It is only slightly darker than the darkest value on her forehead.

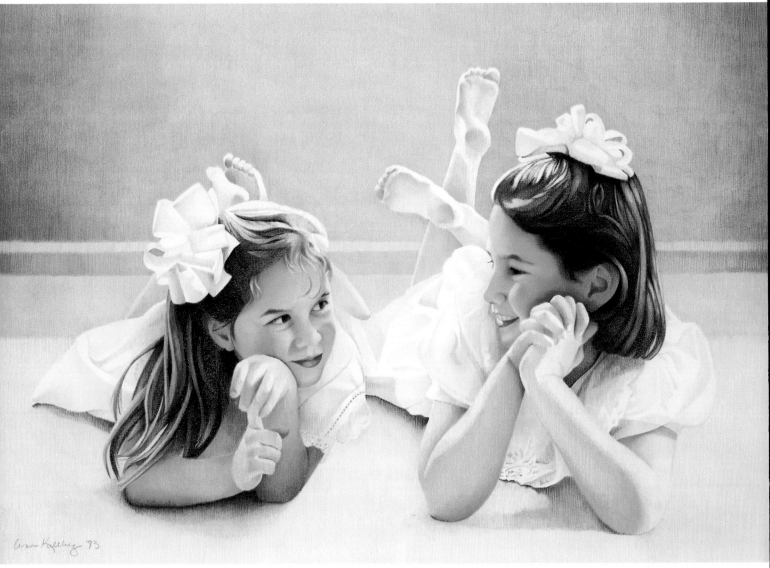

You can see the entire range of skin tones represented in this portrait, from the lightest washes on the feet to black on a tiny shadowed area of the older sister's neck. The range of skin tones is especially dramatic here because of the bright light, but even with softer light, don't be afraid to push the values a little. It adds punch and ensures that arms, legs and faces won't look flat and pasty.

SISTERS
18″ × 25″ (45cm × 62.5cm)
Collection of MacGregor and Lisa Hall

HINT

Here's an example of what happens when you skip value groups. Instead of a smooth, believable transition into a darker skin tone, the Terra Cotta and Dark Brown layers look pasted on and unnatural. Skipping value groups often just makes skin look dirty and rough, rather than darker.

More Skin Tones Step by Step

This next demo shows how many different shades and values one pair of arms and legs can have. Although all but the darkest areas are begun with Cream and Light Peach, different color choices and pressure applied along the way result in over a dozen subtle skin shades.

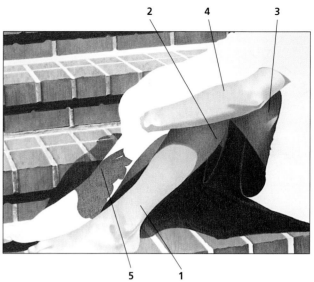

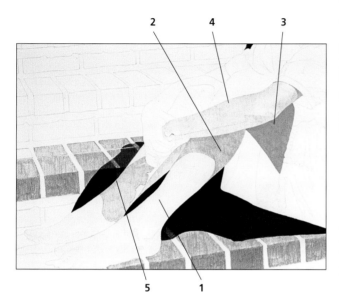

1 These will remain the lightest areas on the legs. I have applied both the Cream and Light Peach washes on these sections.

2 This upper calf is heavily shadowed by the arm, so it will be several values darker than the lower leg. After the washes, I applied Jasmine, Deco Pink and Peach with medium pressure.

3 The thigh is so deeply shadowed that my first wash was Yellow Ochre, with light pressure, instead of Cream. I followed this with Blush Pink, Peach, Goldenrod and Mineral Orange, all applied with medium pressure.

4 After applying the washes to the arm, I lightly layered Jasmine and Deco Pink. I then covered that with Yellow Ochre and Peach just in the area shadowed by the sleeve.

5 This will actually end up being the darkest area on his legs and arms, but at this point I have begun with only a slightly darker than usual wash of Jasmine, followed by a light layer of Peach.

1 On the foot, I've very lightly introduced Jasmine, Deco Pink and Peach, then applied a light coat of Yellow Ochre between his toes and on parts of the ankle area. On the shin and calf, I introduced Jasmine, Deco Pink and Peach, all with a very light touch. I next lightly introduced Yellow Ochre, increasing my pressure slightly toward the bottom edge of the leg.

2 I layered Goldenrod, Blush Pink, Mineral Orange, Pumpkin Orange, Pink, Light Umber and Burnt Ochre over the entire area, then introduced Sienna Brown, Dark Brown, Dark Umber and black to the far left shadowed area. (Although I haven't included Sienna Brown in the skin-tone list on pages 42-43, I do occasionally use it, as well as the greys, Pale Vermillion and even Blue Slate.)

3 This area received the same layers as on the upper calf, except that I added Tuscan Red under the black in the darkest areas. The small highlighted section was not covered with those layers. I lifted a small amount of the previous washes from the upper portion of the highlight with "sticky stuff." The bottom portion of the highlight was layered with Yellow Ochre, Blush Pink and Pumpkin Orange. The thigh and upper calf are now complete.

4 Over the Deco Pink, I began modeling by introducing Peach, Blush Pink and Yellow Ochre. On the more deeply shadowed areas, I layered Goldenrod, Peach again, Blush Pink again, then Mineral Orange and Burnt Ochre.

5 To bring this shadowed area up quickly, I covered the Peach with a medium pressure layer of Henna to make sure it is a warm dark, then followed that with a layer of Dark Brown, using medium pressure.

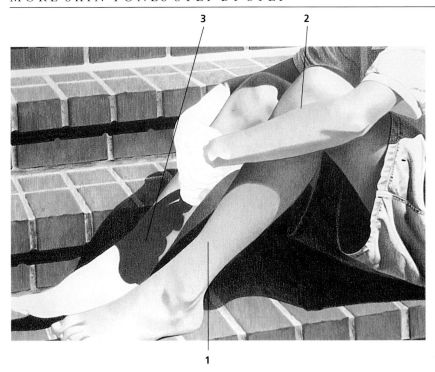

1 Varying my pressure, I carefully layered Blush Pink on and between the toes and over the shadowed ankle areas. Next, I lightly layered Blush Pink over the entire shin and calf, increasing my pressure along the top and bottom edges of the leg.

2 I carefully introduced Blush Pink to the top of the forearm. On the small cast shadow on the upper arm, I layered Mineral Orange, Burnt Ochre, Henna and Dark Brown, all with light to medium pressure. The shadowed area at the bottom of his forearm received a medium coat of Blush Pink, followed by an introduction of Light Umber. I used a heavier pressure toward the top of this shadow than at the bottom.

3 This shadow, while dark in the previous shot, lacked richness and depth, so at this stage, I used Pumpkin Orange, Henna, Tuscan Red and Dark Brown with medium to heavy pressure. This shadowed area is now complete.

1 I introduced Yellow Ochre to the top of his foot and to the ankle area, then darkened the toe shadows with Goldenrod, Mineral Orange and Pink. On the stronger shadow cast by the little toe, I also added Terra Cotta and a touch of Tuscan Red. The lower leg lacked warmth, so I went back to Yellow Ochre, layering lightly over most of this area. I then introduced Goldenrod, Mineral Orange and Burnt Ochre to the top and bottom edges, finishing with a very light introduction of Terra Cotta.

2 First, I covered the bottom shadowed area with Blush Pink, using medium pressure, then layered Burnt Ochre and Sienna Brown over the darkest part of this shadow. With the shadow complete, I began blending the skin tones with Yellow Ochre, Peach, Blush Pink and Yellow Ochre again, all with medium pressure.

Black Skin Tones Step by Step

Let the following demonstration be a guideline for black skin, not a formula! There's no substitute for careful examination and interpretation of your reference photos, since skin of all types comes in so many shades. Although I began with a darker wash here, I still slowly built this subject's skin tones by moving up through the value groups.

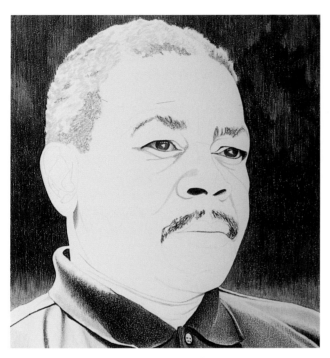

1 Establishing Features
After completing this subject's eyes and laying in his mustache with black and his eyebrows with Sienna Brown and black, I darkened his nostrils with Dark Umber and black. Next, so I wouldn't lose these lines under washes, I outlined facial lines with Mineral Orange, Sienna Brown and Light Umber.

2 First Wash
I chose Rosy Beige as the first wash, not covering highlighted areas.

3 Second Wash
I covered the Rosy Beige with a wash of Jasmine, using medium pressure.

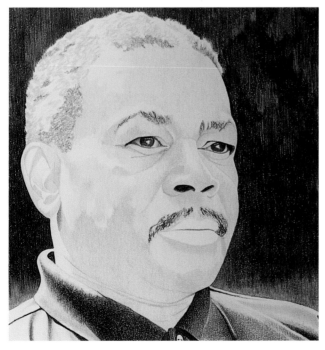

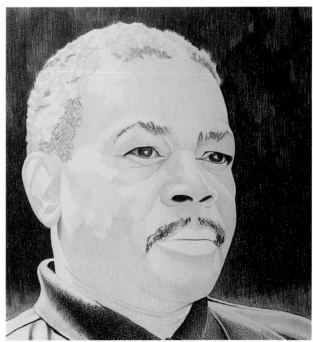

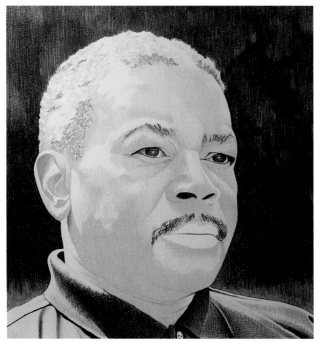

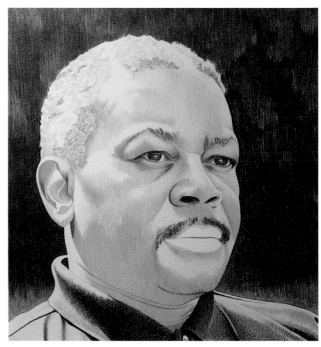

4 Introducing New Colors
Next, I introduced Peach, beginning to do some modeling by increasing my pressure slightly in darker areas. I followed the Peach with Goldenrod on the bottom half of his face and his left cheek. Parts of his ear were covered with Deco Pink, Pale Vermillion, Pink, then Pale Vermillion again, all lightly applied.

5 Building Darker Areas
Here I've introduced Goldenrod, Rosy Beige and Burnt Ochre to many of the darker areas around the eyes and nose, going as dark as Dark Brown in a few spots. I've also slowly increased my pressure in certain areas to medium heavy. I've added small amounts of Clay Rose, Light Umber, Burnt Ochre and Dark Brown on darker sections of his ear.

6 Layering More Darks
Now I've added Light Umber and Sienna Brown to the side and lower half of his face, with a touch of 50% French Grey under his nose.

7 Final Darks
After layering Dark Brown and Dark Umber on the neck and lower cheek, I evened out his skin tones with Rosy Beige, Peach, Burnt Ochre and Mineral Orange, varying my pressure from light to medium-heavy.

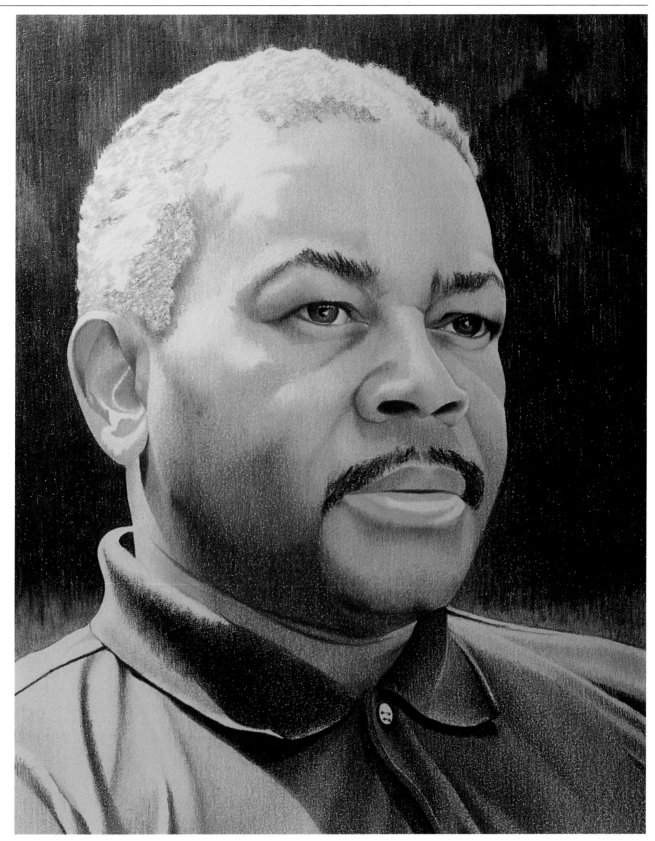

8 Final Touches

For the finishing touches to the skin, I added a bit more Pink and Pale Vermillion to the translucent portions of his ear, then lightly layered Rosy Beige and Peach on the highlighted area of his neck. (Techniques for painting eyes, lips and hair are covered in chapter five.)

Asian Skin Tones

As I mentioned earlier, the skin tone value scale is useful for all shades and hues of skin tones. With darker skinned people, I generally start a little higher on the scale for my first washes. I may begin with Jasmine for Asian or Hispanic skin tones instead of Cream. Then, while building the values, I make choices within each value group, leaving out some of the pinks, for example, when rendering Asian skin.

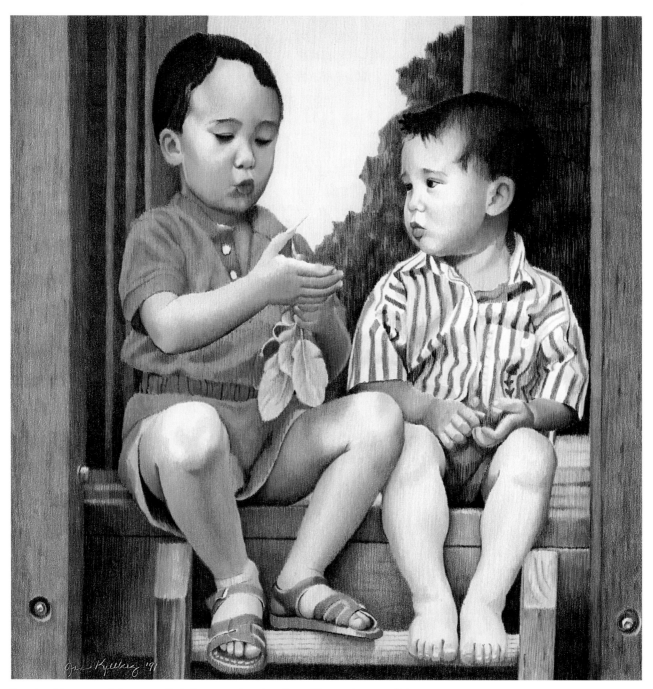

For the skin tones of these cute little Japanese-American boys, I've used more of the colors from the yellow group than the pink. The pinks I chose were of the grey-pink hues, such as Pink Rose, Rosy Beige and Clay Rose.

RADISH FARMERS
18″ × 18″ (45cm × 45cm)

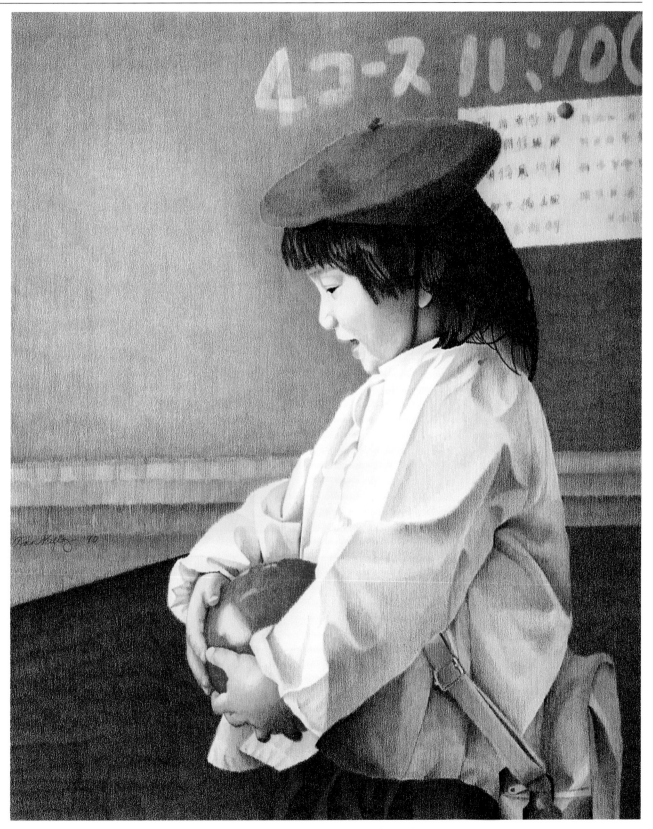

I've used only a touch more of the yellow hues on this sweet kindergartner, letting her features convey her Japanese heritage more than her skin tones.

RED BALL
18″×22″ (45cm×55cm)
Collection of Jerilyn Domagala

Painting Features and the Face

Now we get to the heart of a portrait—the face. I've been intrigued by drawing the face for almost as long as I can remember. Truthfully, though, I don't believe it is the actual features of the face that I'm attracted to at all. What really draws me is expression. And capturing expression isn't always easy. You need skills in both observation and drafting to really capture human expression. It does help tremendously, though, to have a clear idea of the different aspects of each of the facial features. Once you really know how each feature is put together, it becomes far easier to notice the nuances that capture both an individual expression and a likeness.

It would be easy to slip into a "teaching you how to draw" mode in this chapter, but I believe that would be going beyond the scope of this book. I'm more interested in showing you how to use colored pencil to build color and value to add depth and dimension to your drawing.

SAM
21" × 17" (52.5cm × 42.5cm)
Collection of Scott and Margaret Terrall

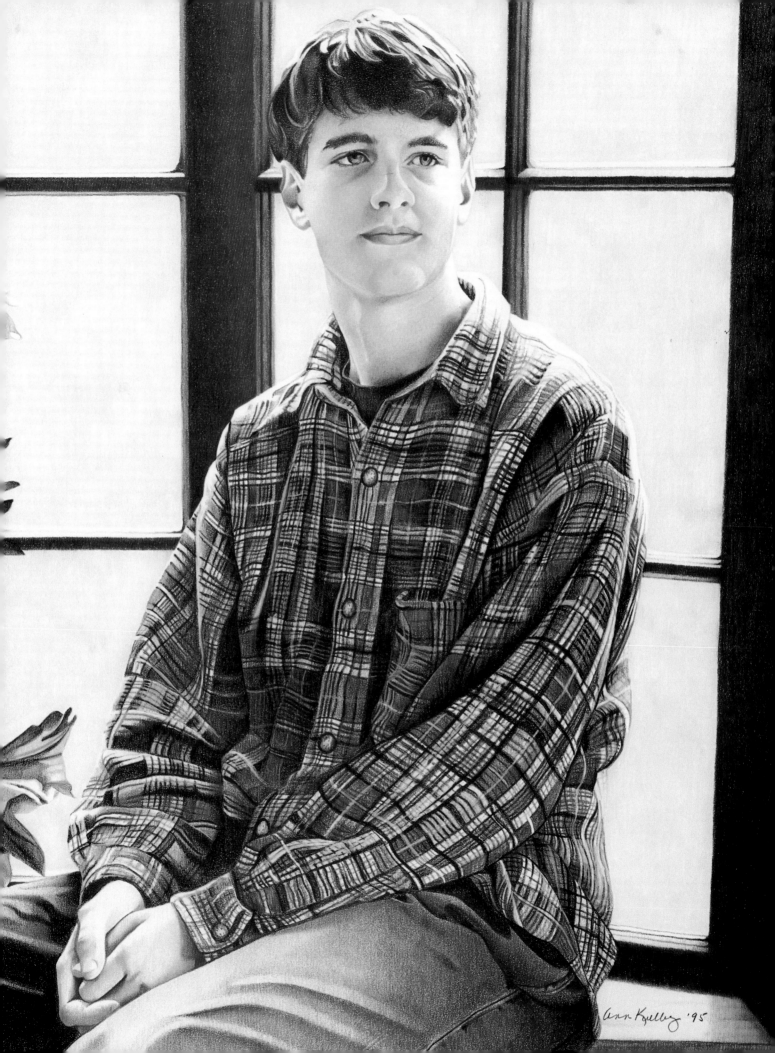

The Mouth Step by Step

I've read that John Singer Sargent once said, "A portrait is a painting of a person where there's something a little wrong with the mouth." You don't know how relieved I was to read that. If even John Singer Sargent had trouble with mouths, then I had every excuse to have the same! And mouths can be troublesome. For one thing, they don't actually *end* in a well-defined line; the edges just sort of drift off into the skin. And with open mouths, you have to contend with inside shadows and teeth. I've chosen to show two open mouths in the following demonstrations, since I think the smiling mouth is one of the more difficult aspects of a portrait. Hopefully, these will help you paint portraits where there's something a little *less* wrong with the mouth!

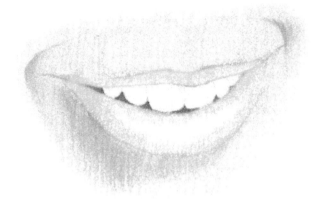

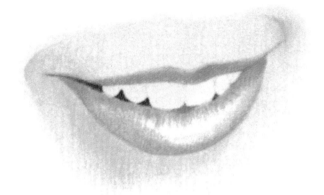

1 The Inner Shadows and First Wash
I've begun with the darkest area, using Burnt Ochre followed by Sienna Brown. It makes sense to use the reddish browns for these inside shadows, since the inside of the mouth is basically pink and the shadows should reflect that hue. Next I applied a light layer of Deco Pink, leaving the center of the bottom lip alone for the curved reflection often found on the lower lip.

2 Building the Darks
First, I've darkened the inside shadow with Dark Umber and layered Peach, Mineral Orange and Carmine Red on the lips, using a heavier pressure on the upper lip. If the face is lit from above, as is usually the case, the top of the upper lip casts a shadow onto itself, so it's often darker than the bottom lip.

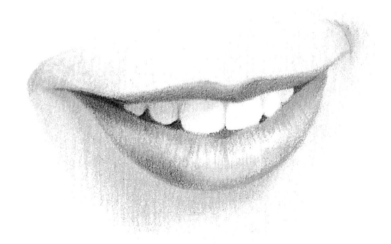

3 The Teeth
I've darkened the upper lip a bit more with Henna and Terra Cotta, then moved on to the teeth. The lines between teeth can be a little tricky. I usually use a very sharp 20% French Grey topped with a light layer of Peach, as I did here. The last step is to lay a very light coat of Cream on the teeth. To keep the teeth from looking flat and pasted on, you need to darken them in both corners. This helps curve these side teeth into the mouth. Here I've used 10% Cool Grey on the far right tooth, and 20% French Grey, Jasmine and Yellow Ochre on the two left teeth to reflect the shadow cast on them by the lip.

1 The Inner Darks and First Wash
First, I layered the corners with Sienna Brown and Dark Brown. Next, I covered the lips with Blush Pink. This little guy's baby teeth are spaced a bit far apart, so I needed more than just the light grey and Peach between the teeth. I chose Clay Rose for the first layer here.

2 Building the Darks
The lips each got layers of Peach, Mineral Orange and Carmine Red. I then applied light layers of Pink Rose and Rosy Beige to the upper gums.

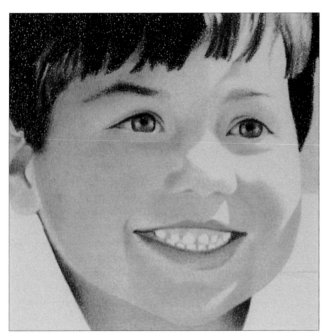

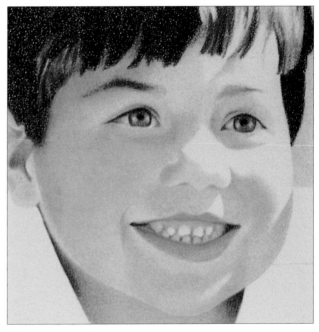

3 Final Darks
I finished the lips with Scarlet Lake and Terra Cotta using medium to heavy pressure.

4 Completing the Mouth
Deco Pink and Peach finished up the gums. Warm tones added over the Clay Rose on the spaces between teeth completed the mouth.

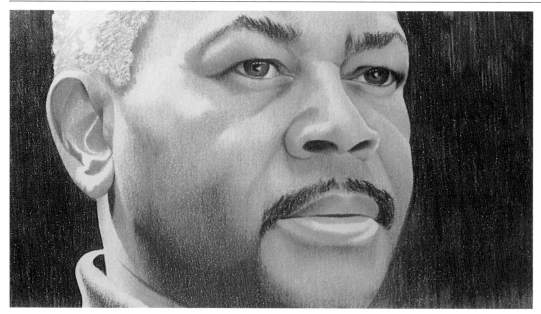

1 **First Wash and Building Layers**
After covering the line between the lips with Terra Cotta and Dark Brown, I started with a light layer of Peach on both lips. Next, I added Rosy Beige, Mineral Orange, a touch of Henna and Clay Rose to the top lip. On the lower lip I layered Blush Pink and Deco Pink over the Peach. Just in the bottom center of the lower lip, I lightly added Pale Vermillion.

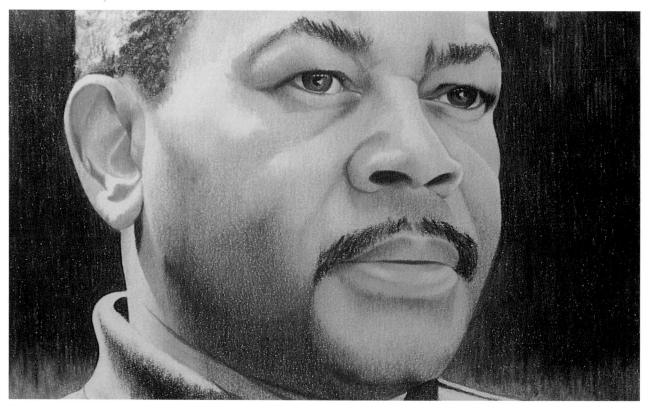

2 **Final Touches**
I added a few strokes of Light Umber to the upper lip, then added Pale Vermillion to the top of his lower lip. Next, I used Clay Rose below the highlight and finished by pulling a little Deco Pink across the highlight.

The Ear

The ear is a feature I've always found relatively easy to render. There's really not an awful lot to rendering an ear. If you follow the values of your reference photo, making sure the inner hollow is dark enough, you should have no problem.

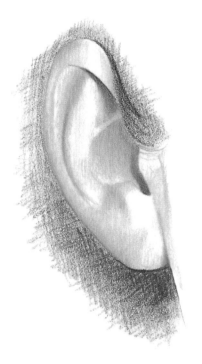

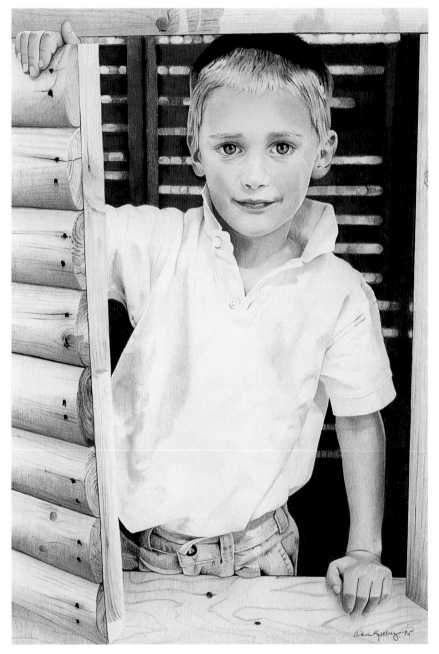

I use a lot of pinks and oranges when rendering an ear. The skin and cartilage are thin, so any light going through the ear looks quite pink. Don't forget the little shadow at the bottom of the ear where it attaches to the face—there's almost always one there.

Looking at Nick's left ear, you can see all three values are represented. The dark values in the hollow and below the upper rim help those areas recede. The highlighted light values come forward. The midtone values shape the rest of the curves and bends of the ear.

NICK
15″ × 23″ (37.5cm × 57.5cm)
Collection of Peter and Sally Miller

The Nose

I've never found noses to be terribly difficult, but I do have a couple of tips. Being the most pronounced feature of the face, the nose generally has a rather strong highlight—usually on the tip and coming down the center. Don't be afraid to make the nostrils too dark; use reddish browns as the undertone here. Be sure to darken the area where the sides of the nose meet the face or the nose will look flat.

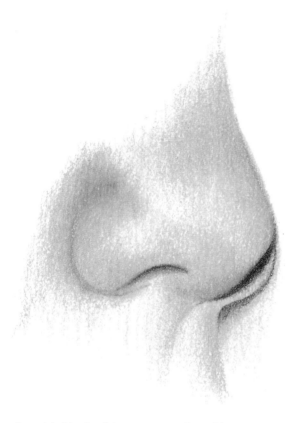
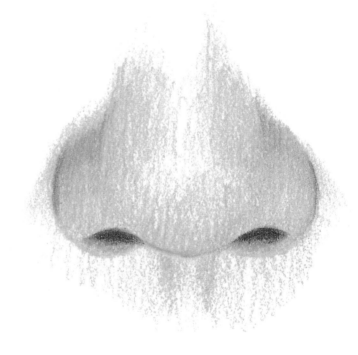

I modeled both of these noses starting with Cream and Light Peach and gradually building up the skin tones. I used Terra Cotta under the Dark Brown in the nostrils.

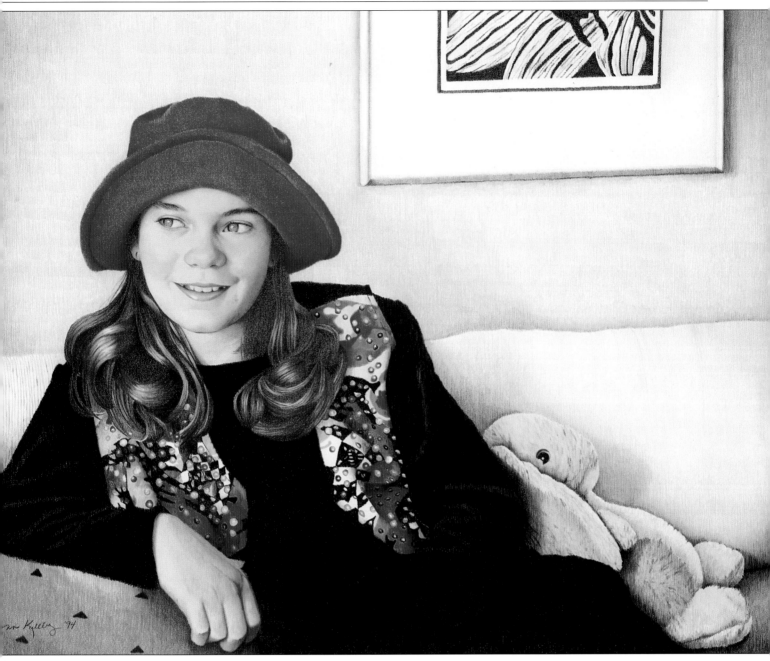

You can see the modeling on Allison's nose is very subtle on the highlighted side of her face. Most of the shaping is done on the shadowed side. The nostrils are dark enough to make them recede into the face. The values darken slightly right below the tip of her nose to add depth by suggesting that this area is shadowed by the tip. The small, slight highlight on the tip of the nose lets the eye "read" that this is the area of the nose that protrudes the most.

ALLISON
18″ × 22″ (45cm × 55cm)
Collection of Susan Monti

The Eyes Step by Step

Let's face it, if you don't have the eyes right on a portrait, you're in trouble! For me, they are the most thrilling part of the face. I will happily confess that I love drawing eyes. It took me a long time to really see all the parts of the eye, though. What helped me tremendously was to keep a mirror close to my drawing table. When I had trouble with an eye, I'd look at my own, until gradually I began to understand all the parts to this incredible feature.

I have a dear friend who is a psychiatrist. Feeling a little intimidated one day, I asked if he "analyzed" me as I talked to him about the goings-on in my life. His reply was perfect: "When you look at me, are you measuring the distance between my eyes and noticing the shape of my nose and mouth?" I had to laugh. No, I certainly wasn't! The point is, we see faces every day, but really *looking* at them is hard work.

So, before moving on to the two following eye demonstrations, go get a little mirror and as you follow the steps, look at the parts of your own eye. When you're working on a portrait, even with an 11″ × 14″ (27.5cm × 35cm) enlargement, the eye in your reference photo is often small and hard to see. It's really helpful in those instances if you already know exactly what makes up an eye—"fudging" becomes much easier!

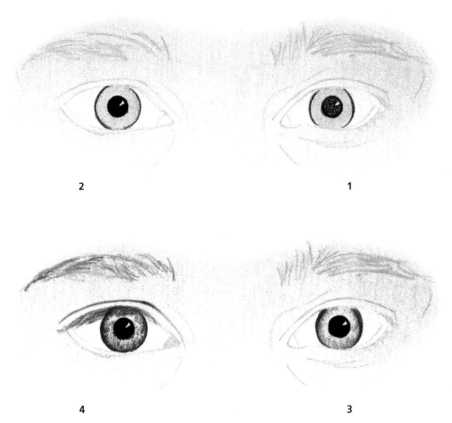

2 1

4 3

1 Outline Rim and Fill in Iris and Pupil
I always start the eye by first outlining the rim of the iris. The rim is usually quite dark, so with blue eyes, I start with Indigo Blue. For brown or green eyes, I use Dark Umber on the rim. My next step is to apply a very light layer of Cloud Blue over the iris. (For brown or green eyes use Jasmine.) I then fill in the pupil with a heavy layer of Indigo Blue, leaving the highlight white.

2 Add Second Wash and Darken Pupil
The difference is slight, but here I've added a light layer of Deco Blue over the iris, then darkened the pupil with black. It's important to get the pupil intensely dark. Use plenty of pressure to burnish this area.

3 Build Iris Color and Re-Rim
First, I've layered the iris with Blue Slate. I do this carefully by starting at the outer rim with medium pressure, then decreasing my pressure as I move toward the pupil. I want to leave the area immediately around the pupil with only the first two light layers of blue. This will help to give the iris a translucent quality. Next, I rim the iris again, this time with True Blue.

4 Finish the Iris and Add Details
I completed the iris by going in with tiny amounts of True Blue and Periwinkle Blue with a rough, choppy stroke, still leaving the area around the iris lighter than toward the rim. Next, I darkened the eyelid line with Terra Cotta. Don't be afraid to go too darkly with this line. Having a strong eyelid line really helps to give the entire eye depth. Without it, the eye can look flat. After lightly applying Deco Pink to the inside corner of the eye, I used Dark Brown and laid in some lashes.

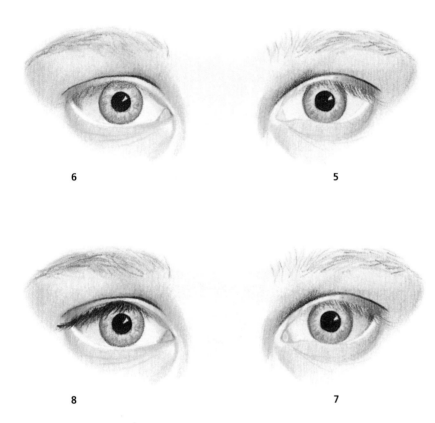

6

5

8

7

5 **Darken Skin Tones and Eyelid Line**
I know it looks like a lot has happened here, but all I've done is darken the skin tones around the eye, as well as darken the eyelid line even further with Dark Umber. I tend to leave the skin tones on the center of the eyelid slightly lighter than in the corners; this helps make the eyelid look round. A common mistake is to bring the skin tones of the bottom lid right up to the eyeball. You need to leave space here for the upper rim of the lower lid. We don't focus on this eye part when we look at someone's eyes, so it tends to be forgotten. But that rim is essential to making the eyeball sink into the face. (Look in a mirror to notice the relatively large space between the top of the bottom lid and where the bottom lashes begin—you'll be amazed!)

6 **Model Whites of the Eyes**
I've now modeled the whites of the eyes with light greys and a touch of Cloud Blue. To make sure the eyeball reads as round, you need to darken the sides. White eyeballs just look flat.

7 **Model Inner Corner**
Using tiny amounts of Blush Pink, Mineral Orange and Burnt Ochre, I modeled the inside corner of the eye. I left the middle section lighter to suggest a soft highlight. This part of the eye is wet, so any light hitting it often results in a tiny highlight.

8 **Darken Lashes**
Using Dark Umber and black, I've darkened the eyelashes.

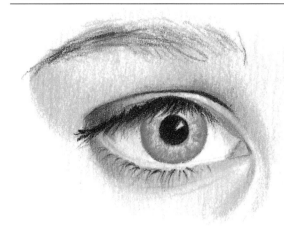
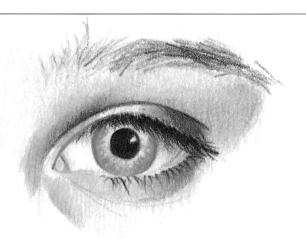

9 **Complete the Eyes**
I added the lower lashes, first using Light Umber, then Dark Brown. The last step was to add a bit of Light Peach followed by Deco Pink on the upper rim of the lower lid, and the eyes were complete.

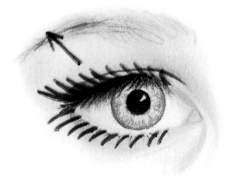
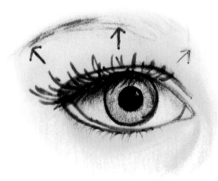

Poorly drawn lashes can ruin an otherwise perfectly lovely eye. One of the most common mistakes I see is drawing all of the lashes going the same direction. They just don't grow like that!

Follow these arrows to make your lashes look much more realistic.

HINT

Don't panic if you haven't left enough lighter values around the pupil. There's an easy fix that works quite well. Using a very sharp point, burnish this area with white. You'll get the translucent quality back, and the area will look luminous, which is exactly what you want!

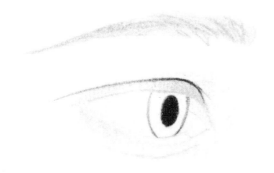

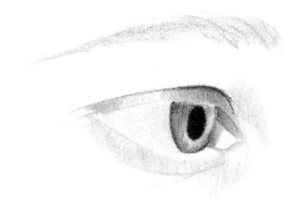

1 Outline Rim and Add Washes
This demo simplifies the process to its basic steps. First, I put in the outer rim of the iris, next the pupil, then the eyelid line.

2 Complete Iris, Model Whites and Skin
I finish the iris, then darken the whites of the eye. Next, I put in some skin tones, including in the inside corner of the eye.

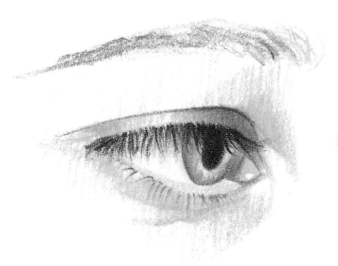

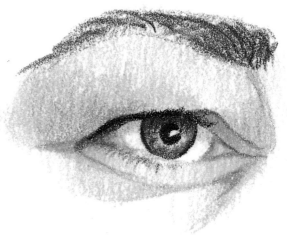

3 Finish Skin and Lashes
I further darken the skin tones, then finish with the eyelashes.

Here's an example of an older person's eye. The only real difference is that the lid line merges with the lash line. The eyelid line is really an important part of the eye. To capture a likeness, you definitely have to get the lid line right, so pay close attention to this in your drawing.

Painting the Face Step by Step

Next I'll show you how I combine the features and skin tones to create a face. But I have a word of caution: Take everything I say and show you as *guidelines* only! I certainly have no hard-and-fast rules about the precise order I follow in painting a face. Over the years I've experimented by starting with different elements. Now I generally start by outlining the features, then moving on to the first two skin "washes." You may find you prefer to finish the eyes first or finish the skin tones before working on any specific feature. What works for you is what you should do!

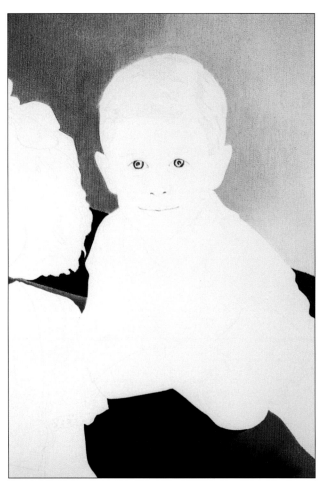

1 Reinforce Pencil Lines and Start Irises
My graphite lines are so light that rather than take the risk of losing them, I go over them with a light line of Light Umber. (Sometimes when I work on other areas of the painting, my arm rubbing against the paper "erases" my graphite sketch lines.) Next, I begin with John's irises.

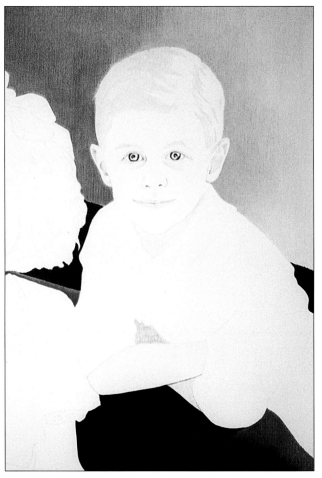

2 Define Darks
Don't be afraid of "ugly stages." I know the drawing looks just this side of hideous at this point, but you have to have faith that things will start to look better soon. I've defined the areas of John's face that will be darkest by lightly applying Peach, varying my pressure only slightly to begin some modeling. I layered Blush Pink over the Peach on his mouth.

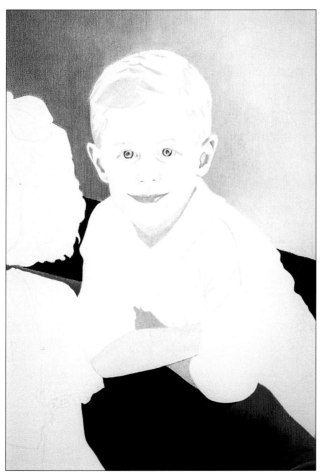

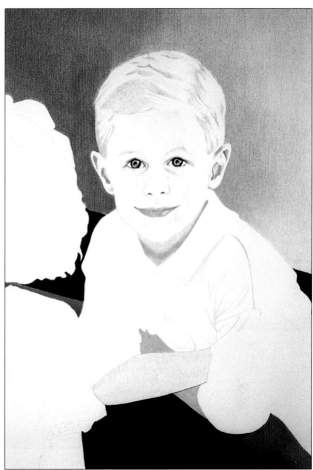

3 Apply Washes
Looking better already, don't you think? I've now gone over his face with very light coats of Cream, Light Peach and Jasmine. I didn't cover the right side of his face with any of the washes since this is a very light highlight. Next, I used Pale Vermillion on his lips and the darker areas of his ear.

4 Work on Lips and Eyes
After adding another wash of Deco Pink to his face, I went back over John's lips with Blush Pink, then Poppy Red. Next, I worked a little further on his eyes.

5 Complete Irises and Darken Mouth Line
Here I've finished the irises and darkened the line between the lips with Dark Brown.

6 Introduce Blush Pink and Work Darks
After a layer of Blush Pink, John looks a bit like he's spent too much time under a sunlamp, but I know the next stage will correct that. This layer of Blush Pink is the first layer that is not just a "wash." In other words, I only covered the areas that are going to be darker in value, and I've varied the pressure to begin modeling. I've also darkened his lips with Scarlet Lake and layered Mineral Orange over his eyebrows and some of the shadows around his nose and eyes.

7 Introduce Yellows
I layered Yellow Ochre over most of the Blush Pink using very light pressure. Next, I used Yellow Ochre and Mineral Orange just over parts of the top half of his face so you could see the difference these warmer colors make. The yellows always seem to bring life and warmth to skin tones. I darkened his eyebrows here with some Light Umber, using medium pressure.

8 Build up Values
Again just working on the top half of John's face, I slowly moved up the skin tone value scale, building up value on the side of his forehead, on his ear and around his eyes. I've used Peach, Rosy Beige, Pumpkin Orange and Burnt Ochre in these areas.

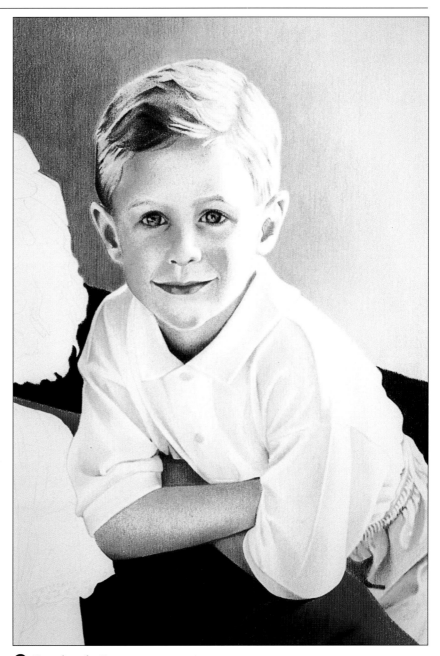

9 Complete the Face
In this step, I've completed the skin tones and added a few final touches. First, I added a highlight to his iris with just a spot of white oil pastel. (There were no real highlights in the reference photo, so I'd originally finished the eyes without them, but at this stage decided they needed a little sparkle. Just adding white colored pencil to the iris at this point wouldn't give a light enough highlight, but a touch of oil pastel worked just fine.) Next, I darkened his nostrils and lips, using Terra Cotta, Tuscan Red and Dark Umber. Once those darkest areas were in, I could concentrate on evening out his skin tones. First I darkened some of the shadows around his eyes with more Mineral Orange, Burnt Ochre and Terra Cotta, using medium to heavy pressure. Next, I went back to Deco Pink, which I layered over much of his face. Going back to this lighter value can help blend the darkest and lightest areas together. The last step was to layer just a touch more Blush Pink once again over his cheeks and the bottom of his chin.

1 Define the Features and Build Skin Tones

After defining the eye and eyebrow with Light Umber, I covered his mouth with a light layer of Carmine Red. Next, I layered Cream and Light Peach over his face with a very sharp point and very light pressure. I then began modeling with Jasmine and Deco Pink, avoiding the areas that will be lighter in value. Next, I used increasingly darker skin tones on his ear, ending with Dark Brown. I worked the ear to a dark value this early because of the distracting white area to his left. I felt I needed a dark on that side to balance the effects of all that white (soon to be his brother).

2 Add Darks

I darkened his eye and mouth, then slowly darkened his skin tones by lightly layering Peach and Yellow Ochre. I defined the side of his nose with a line of Light Umber.

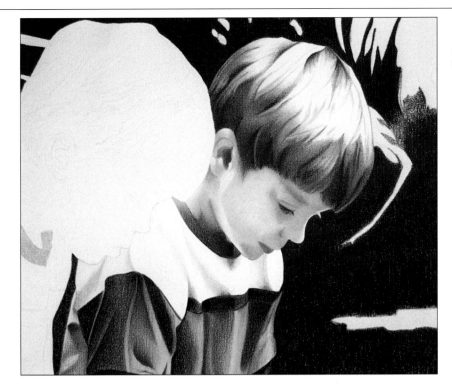

3 Build Skin Tones Further
The next three colors I used to build up his skin tones were Blush Pink, Mineral Orange and Burnt Ochre.

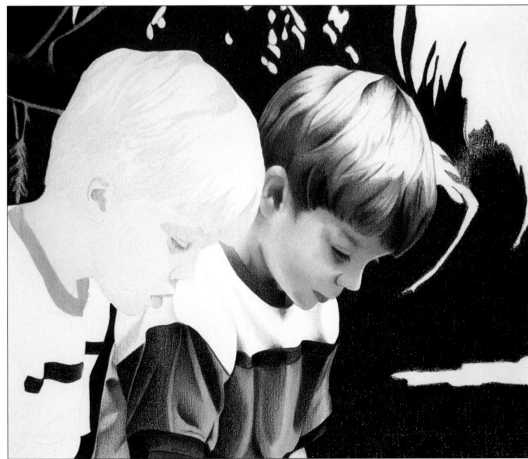

4 Completing the Face
I finished his skin tones with Henna, Goldenrod and Light Umber, then back to Blush Pink. The last step was to darken the inside of his ear one more time with black.

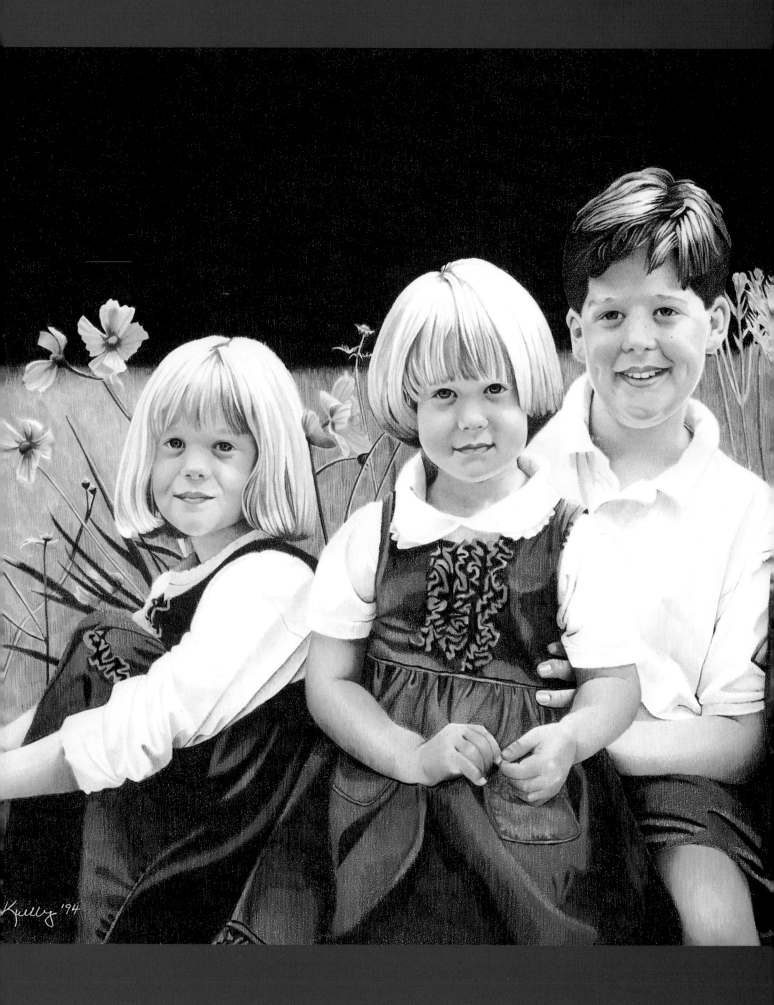

Painting Hair

I won't say that rendering hair in colored pencil is easy. The first few years I worked in colored pencil, I only drew Japanese children—I spent eight years in Japan, and had lots of wonderful photo references to work from. But sometimes I think the *real* reason was that the hair was so easy—always straight, usually short and jet black, with a few highlights. Eventually I had to branch out to other types of hair, so over the years I've developed a method for attacking hair. It's really not as difficult as you might think.

THE MANNIX FAMILY
20″×28″ (50cm×70cm)

Divide Hair Into Shapes

The simplest way to approach drawing hair is to think of the entire mass in shapes: dark value shapes, light value shapes and midvalue shapes (everything in between). If you break it down to those three main shapes, the entire process is simple. With blond or white hair, you first have to find the darks. With darker hair, you need to find the highlights. Regardless of hair color, I always start by establishing the darkest darks first. The highlights are left alone till the end of the process.

If you look carefully at the steps in the following demos, your portraits will have glowing, shiny, healthy-looking hair in no time.

First, lay a clear piece of acetate over your reference photo. Then, using a permanent marker, circle the areas that are most highlighted.

Keep this marked acetate next to your reference photo as you work.

HINT

When drawing brown and black hair, before you make a single stroke, first look for the highlights. This is essential, since you will be leaving the highlighted areas of dark hair alone until the end of the drawing process. Initially, you will only be working with the dark and medium values. Until seeing the highlights becomes automatic, it may be helpful to actually mark the lighter areas on your drawing before you begin work.

Painting Dark Hair Step by Step

I love the chance to paint hair dazzled by sunlight! There is something absolutely thrilling to me about the juxtaposition of the very dark and very light values and the way the two blend and merge into each other. The next two demonstrations are perfect examples of dark hair with "high drama."

You can see that the darker shapes in this example are relatively flat. In other words, the hair is all one value, except for the tiny highlighted area in the larger dark. Since the hair is flat, with no gradual changes in value, you can cover it quickly with the three-step method illustrated on page 15, using Dark Umber and black.

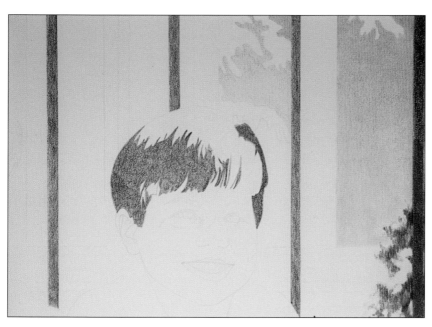

1 First Dark
Using medium to heavy pressure and a sharp point, begin rendering the darkest shapes with a Dark Umber pencil. Leave the small section of highlight within the larger dark shape white.

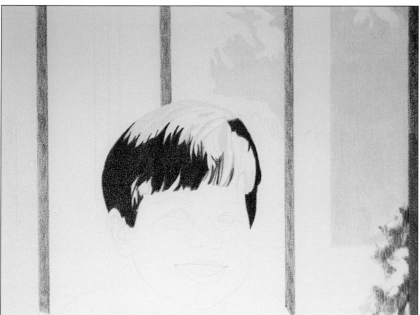

2 Second and Third Darks
The second layer is black, applied with heavy pressure and a fairly sharp point. (When using heavy pressure, a very sharp point will break right off, so just sharpen to the "almost sharp" point.) Your final layer is Dark Umber again, heavily applied this time.

HINT

If you look at the hair toward the back of the head, you'll notice two things: First, you'll see that it is a fairly dark value. This creates the illusion that the head is curving back away from you at that point. The second thing you'll notice is it's quite dark at the part, then the value lightens up quite a bit, then gradually darkens again until it meets the very dark value on the left. Going from dark to light to dark again helps to give the appearance that the hair curves along the head. Whenever you want hair to curve, curl or wave, just remember to move from dark to light to dark again.

Now that you have your darkest values established and your whitest white is the paper surface, you're ready to move to the next step. The highest highlights in this little boy's hair will never be covered with any pencil at all—you will simply let the paper act as your lightest value. So, since in this example the dark area and the highlights are flat (no gradation of value), you must do all of the modeling in the medium values. To do this, you need to divide these medium tones into several shades or values, which will create the illusion of "sections" of hair, as well as give depth, volume and form. This "sectioning" saves you from having to draw individual strands of hair, which I *know* you'd rather avoid!

Another way to look at it is that to begin with, you have three values:

- Darkest—The darkest value is flat, with no gradations of color or value, no sections or strands of hair and no highlights.
- Lightest—The lightest value is equally flat since it is simply the color of the paper.
- Midrange—After the first "wash" of Yellow Ochre, the midrange values are also flat, since you only have one color down, using only one level of pressure.

By covering only parts of the first "wash" with Goldenrod, a slightly darker pencil than Yellow Ochre, you will start to create sections of hair. When you add a third color, Burnt Ochre, you will divide the sections further. When you vary the pressure of your Burnt Ochre application, you will divide the sections even more. And by making the midvalues darker toward the back of the head, you create form and depth. By layering three colors and creating five values, you will have started to turn this flat area into a shiny, round head of hair!

- First value—Yellow Ochre
- Second value—Yellow Ochre and Goldenrod, light pressure
- Third value—Yellow Ochre and Goldenrod, medium pressure
- Fourth value—Yellow Ochre, Goldenrod and Burnt Ochre, light pressure
- Fifth value—Yellow Ochre, Goldenrod and Burnt Ochre, medium pressure

Yellow Ochre only

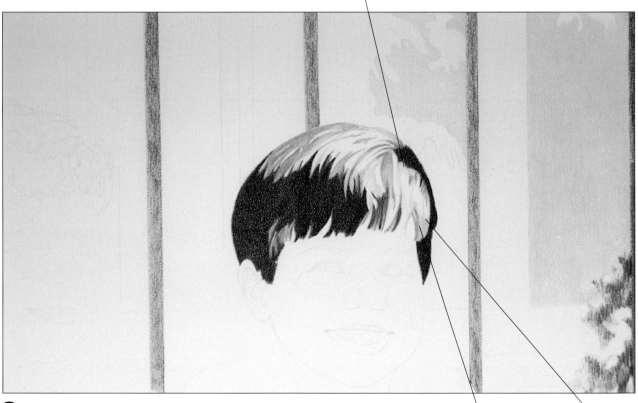

Yellow Ochre, Goldenrod and Burnt Ochre

Yellow Ochre and Goldenrod

3 Midtones

First, "wash" the areas that are not highlights with Yellow Ochre, using light to medium pressure and a sharp point. Look carefully at your reference photo to see where some of the midvalue tones are slightly darker. Layer Goldenrod over some of the first layer of Yellow Ochre. Next, use Burnt Ochre to go over some of the areas covered with both Yellow Ochre and Goldenrod. Vary your pressure from light to medium-heavy for both colors.

The final step in creating this head of hair is to soften the value differences between the dark and medium tones. Use the same colors used to create the darkest values, but with a lighter touch this time. I've actually added very little pencil here—just enough to make the transitions from dark to medium tones less dramatic and to divide a few of the larger sections into smaller sections. Although there's little to it, this last step really brings out the highlights by making sure there are enough little darks among the midrange values to really pop out those highlights.

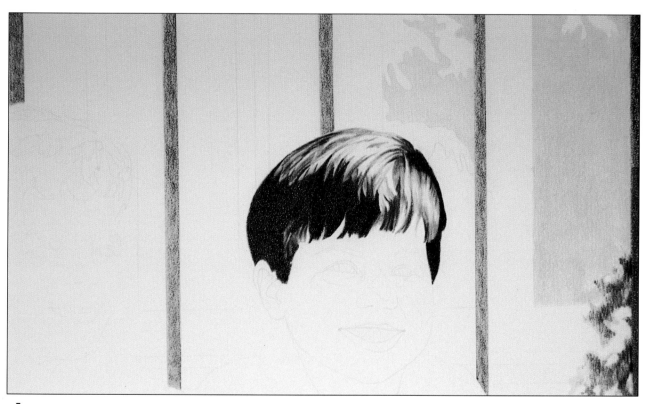

4 Completing the Hair

Use Light Umber to divide a few more of the larger sections. Still using Light Umber, layer over the edges where the darkest and medium values meet, using medium to heavy pressure. You want to blur these lines a bit, so don't be afraid of going into the dark area. Finally, varying your pressure dramatically from light to heavy, darken a few of the strands with Dark Umber, particularly around the part and toward the back of the head.

Painting Light Brown Hair Step by Step

In this demo, I follow the same process as with dark hair. First I establish the darkest darks, then move on to the midrange values. My color choices are slightly different, using a little less Dark Umber and quite a bit more of the brownish yellows, such as Jasmine, Yellow Ochre and Goldenrod.

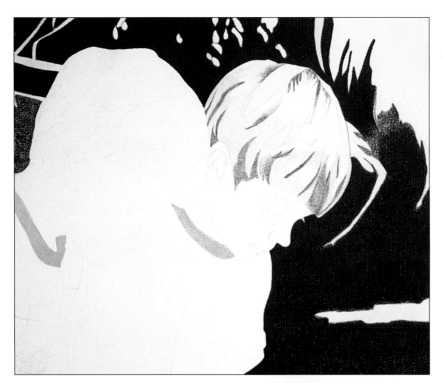

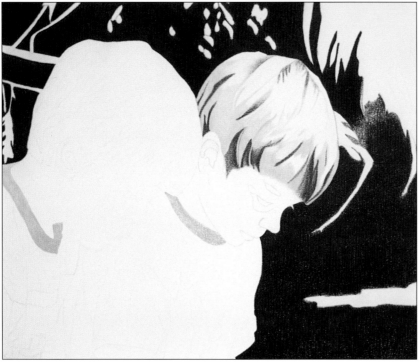

1 First Wash and Darkest Shapes
I began this boy's hair with a wash of Jasmine over all but the highlighted areas, using medium pressure. (If his hair were a lighter brown or dark blond, I would start with light pressure. Since it is a fairly dark brown, I started with medium pressure.) I then began defining the darkest areas by layering with Dark Brown.

2 Building Midvalues and Darks
I wanted to slowly build the value in this area, so using Yellow Ochre, I began modeling, varying my pressure from medium to heavy. Over the Dark Brown areas, I layered Dark Umber, using medium pressure. Next came Tuscan Red in only those areas that will be darkest.

HINT

As I mentioned in the introduction, many of the demonstrations in this book are details from actual commissioned portraits—this is one. You can see I definitely follow my own "rule": If the background area is darker than the values of the face, I establish it first. A detail of the finished portrait is shown in chapter seven.

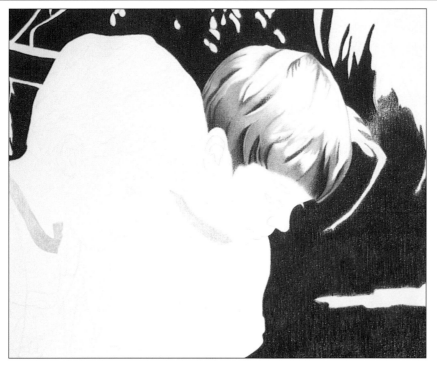

3 Completing the Darkest Values and Continuing Midvalues

I completed the darkest values with black, then re-layered Dark Umber using medium to heavy pressure. With a light layer of Burnt Ochre, I continued to build the medium-value section. Next, I used Light Umber, increasing the pressure around the boy's ear and on the right side of his bangs.

4 Completing the Hair

I still felt this area needed more warmth and depth, so I covered the medium-value areas with a heavy coat of Goldenrod. I finished building the medium values with Sienna Brown and Dark Brown, using heavy pressure to blend the edges between the medium and dark value areas. Using Yellow Ochre, Goldenrod and Light Umber, I softened the darks at the top of the head, then applied Dark Umber in the darkest sections.

Once the medium and dark values were finished, I used Yellow Ochre and Light Umber to lightly pull a few lines through the highlight to suggest strands of hair.

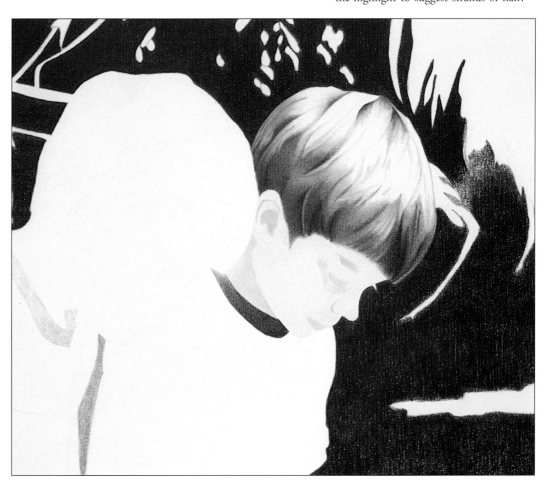

Painting Blond Hair Step by Step

Blond hair can be just a bit trickier than dark hair because you have to be more careful with both your color choices and values. You must have areas that are quite dark to give a sense of volume and to make the lights look light. The trick is learning where to quit with the darker values.

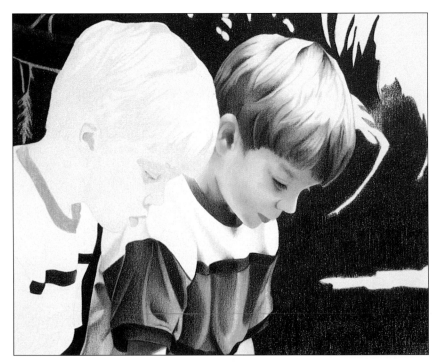

1 First Wash
I started the second boy's blond hair with a wash of Jasmine, using light pressure except at the top of his head, where I increased my pressure slightly.

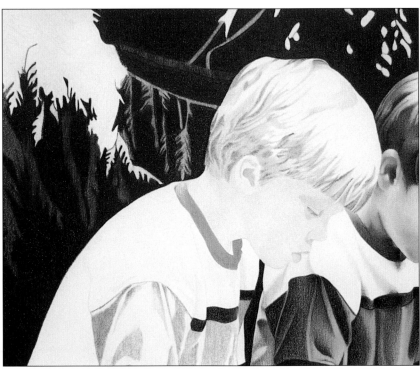

2 Dividing the Value Shapes
Using Light Umber and varying my pressure throughout from very light to medium, I began dividing the hair into smaller sections by value.

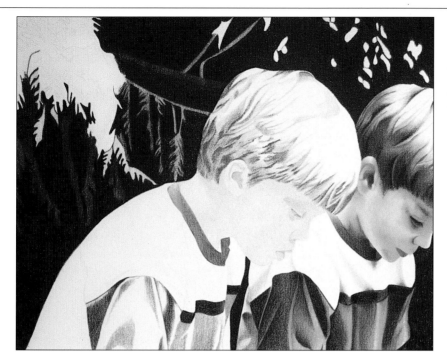

3 Darks

Focusing on just the darkest areas, I layered Dark Brown using very light to light pressure. I didn't want to go too dark, but I also knew that without the darker values to add contrast, texture and depth, the blond hair would look flat.

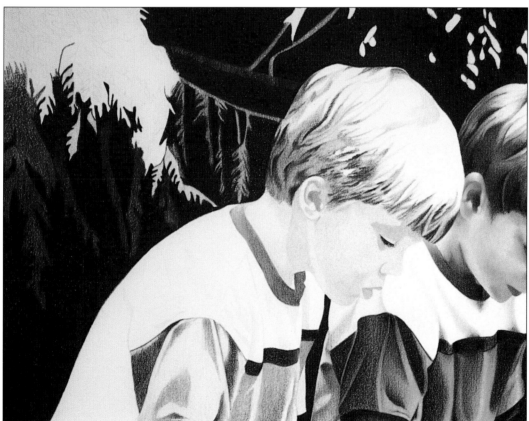

4 Final Darks

One last go at the darks! Using Dark Umber I deepened a few of the darkest areas with a medium to heavy pressure. Since the darks recede and the lighter areas seem to come forward, the contrast between the values provides the illusion of texture and depth. Next, I covered just the back section with light layers of Yellow Ochre, Goldenrod and Burnt Ochre.

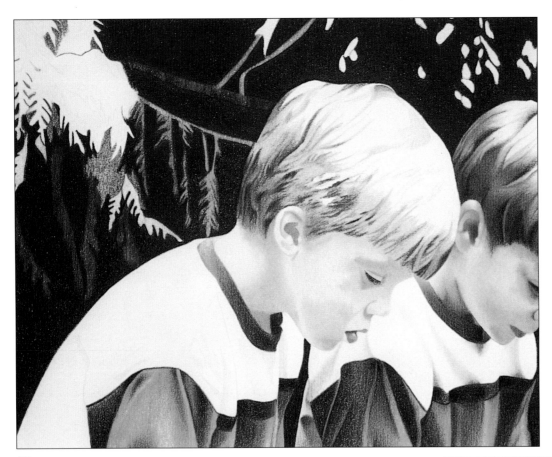

5 Completing the Hair
I warmed and softened edges using Yellow Ochre with medium pressure and Burnt Ochre with light pressure. With a touch of Jasmine, I suggested a few strands through the highlighted areas.

HINT
Although in this particular demo I haven't used any greys, they can be very useful when drawing light blonds and ash blonds.

Red Hair

The first time I had to paint a redhead, I admit I was terrified! What colors would I use? Oranges? Reds? Pinks? After I got started, I discovered it wasn't quite as difficult as I thought it would be. Using the value viewer to isolate small sections of hair, then trusting what I saw in the viewer, I was able to render a believable head of red hair.

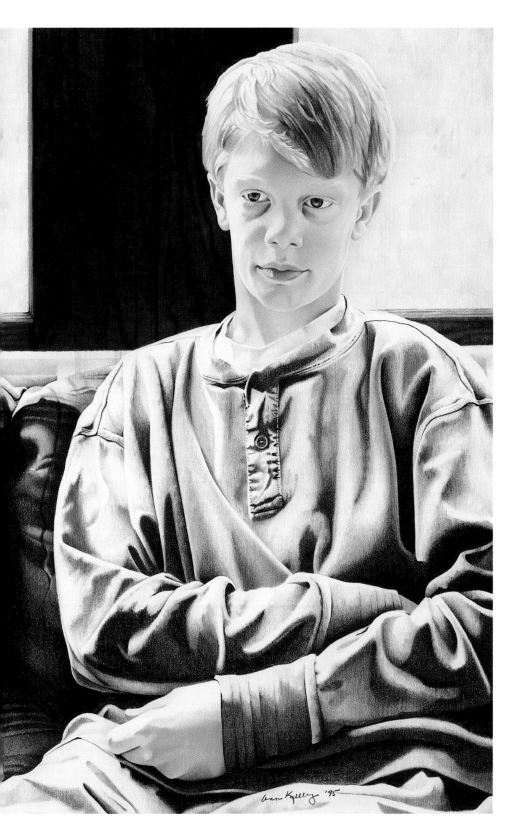

The first wash for Daniel's hair was a light to medium layer of Goldenrod. I chose this as my wash because it is darker and has more orange tones than Yellow Ochre. Over the wash, I built up the values with Mineral Orange, Burnt Ochre, Sienna Brown, Pumpkin Orange, Pale Vermillion, Dark Umber and black. After all the values were established, I added very small amounts of Poppy Red in three or four small areas to add a little punch.

DANIEL
14½″ × 21½″ (36.5cm × 54cm)
Collection of Scott and Margaret Terrall

Curly Hair Step by Step

Although drawing curly hair takes more time than straight hair, it's also a lot more fun! It always seems a bit magical to me to see a piece of flat paper turn into a bouncy little curl. The bonus is that the technique is very simple and always works!

Curling hair is really as easy as this: By changing values from dark to medium to light, then back to medium and dark again, the eye sees a curve. When you throw in a few lines to indicate individual strands, the curve magically becomes a curl.

This example shows how a flat rectangle can look like it's curving. Leaving a narrow middle section white, I've layered warm tones in increasingly darker values on either side of the highlight. The colors I used for this demo were Cream, Jasmine, Yellow Ochre, Goldenrod, Burnt Ochre, Sienna Brown, Dark Brown and Dark Umber.

Here I've used the same color progression but applied most of the top layers in a directional, horizontal stroke instead of a vertical line. I then pulled a few of the darker colors through the highlight to indicate individual hairs or strands. I also made the highlight less regular by shifting it slightly to the right and left of center for a more realistic look.

Line drawing for curl demonstration

1 Darks
I started with a medium layer of Goldenrod in all areas that will be darkest. I then added layers of Tuscan Red and Dark Umber on top of the Goldenrod, varying my pressure from medium to very heavy.

2 Midvalues
Working just on the mid-value areas, I first applied a flat wash of Jasmine, using medium pressure. With a medium to heavy pressure, I added Rosy Beige over the Jasmine, starting to blend some of the edges where the medium values and the darkest areas meet. Next, I layered Burnt Ochre over the Jasmine using medium pressure.

3 Blending Values and Final Darks
Light Umber and Dark Brown went over the midvalues, blending them further with the darkest areas. I then went into the highlights with Pink Rose, softening the edges between the highlights and the medium values. Finally, I added a little more depth and drama by applying touches of black to the darkest areas with heavy pressure.

Kinky or Wavy Hair Step by Step

Through most of the following demo, I've used either the side of my pencil or a dull point to create the rougher feel of this subject's hair. With kinky or wavy hair, you have to pay special attention to the *patterns* the highlights make. These patterns shape the texture of the hair.

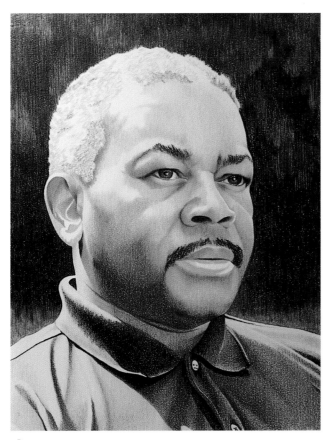

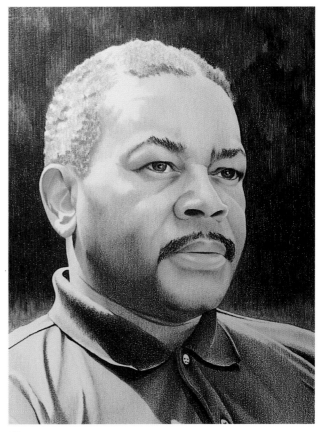

1 Circular Washes
The first layer I used on the hair was Rosy Beige, applied with a light pressure, using the side of the pencil rather than the point. I wanted a rough look and knew the side of the pencil would leave more of the paper surface showing. I used a loose, directional stroke for this layer, a little like the "Brillo pad" method but with larger, more irregular circles. I added Dark Brown with very light pressure to some of the Rosy Beige areas, using a squiggly sort of motion, still using the side of my pencil.

2 Midvalue
Next, I used Sienna Brown over most of Fred's hair, leaving irregular patches of highlights. I used very short, random-direction strokes and varied my pressure to begin modeling.

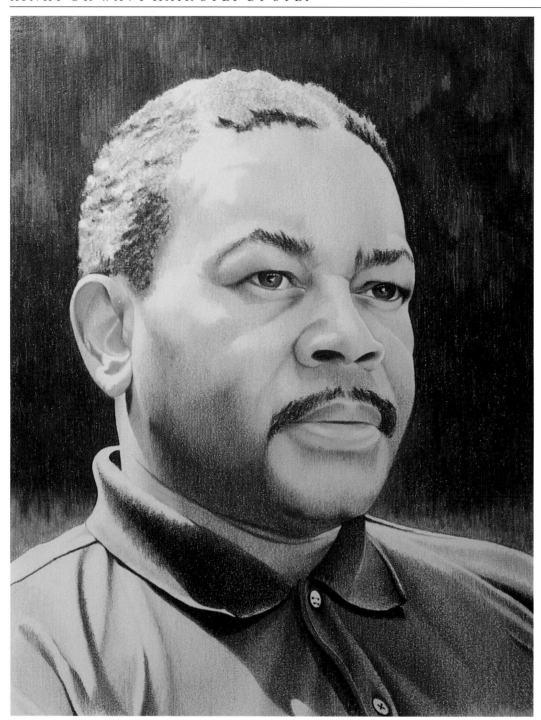

3 Darks and More Midvalues

Over the darkest areas, I squiggled Dark Umber and black, using medium to heavy pressure. The hair was looking more nappy than wavy at this point, so I applied 50% Warm Grey and Sienna Brown over the midtone areas in longer directional strokes. Using a *very* light touch and the side of my pencil, I brushed Dark Umber over some of the highlighted areas to complete the hair.

Brush Cut

The brush or crew cut might look a lot harder than it really is. In fact, two simple tricks that are easy to execute will turn out a soft, fuzzy head of hair (or the fur of a stuffed animal) every time.

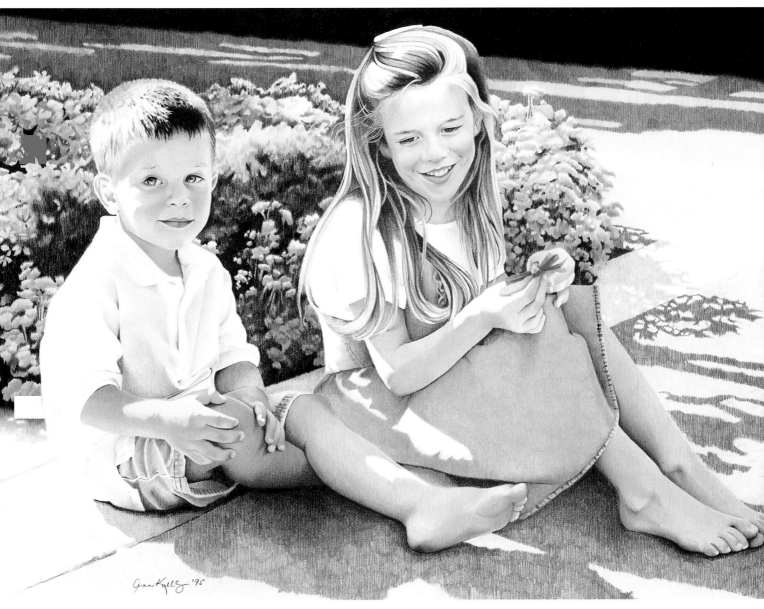

The two techniques to use when rendering very short or brush cut hair are easy to execute. The first trick involves the outside edges of the haircut. If the background is darker than the hair, make little notches into the hair area with the darker background colors. Where the hair is darker, you'll end the edge of the hair with the same small, irregular notches. This alone clearly "reads" as bristly, cropped hair. The second technique is to use very short, directional strokes and not be afraid to add a few dark strokes in the light areas to show volume.

NICK AND SARA
26″ × 17″ (65cm × 42.5cm)
Collection of Mark and Gayle Andrews

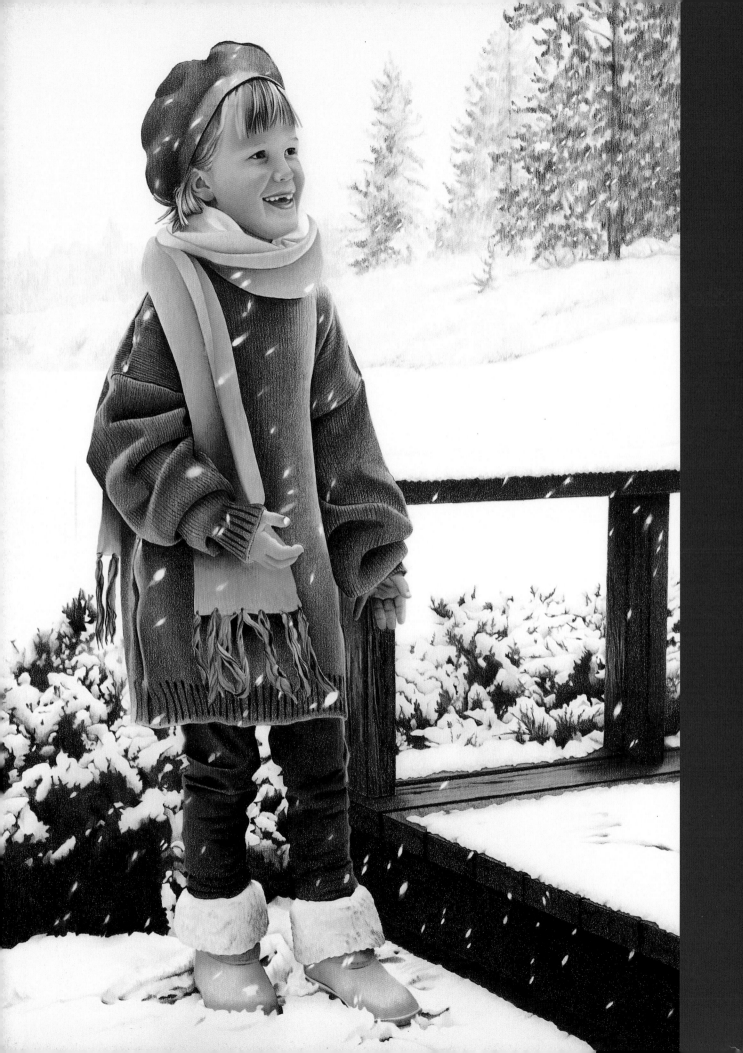

Painting Fabric

Drawing the fabric that clothes your portrait subject can be anything from a fun challenge to a major headache. I generally love rendering the folds and shadow of cloth, but I've had my share of nightmares, too. I once was commissioned to do a posthumous portrait, and in the photograph the family provided me, the gentleman was wearing a sport coat made up of what seemed like millions of very small black and white checks. I thought I would never get through all those tiny checks. As soon as that portrait was complete, I added a new "rule" to my commissions: No checks! (I then had a client who thought I meant she'd have to pay me in cash!) Usually, though, I really enjoy watching the textures and folds of fabric coming alive before me on the paper. The pressure is off when it comes to fabric— there's no "likeness" to capture!

KATIE
22″ × 27″ (55cm × 67.5cm)
Collection of Simon and Lisa Acheson

Solid Cotton Fabric Step by Step

My approach to painting fabric is in many ways similar to how I approach painting hair. First, I look for the highlights, then I define the darkest values. Next, I work in the medium value range, and finally, I add any necessary detail to the highlighted areas.

Fabric in bright sunlight can be a real joy to render. With lots of contrast and reflective color, working on these shorts was just pure pleasure. I especially love painting the little puckers of hems and seams that add so much realism with so little effort.

1 Washes
The light was far less dramatic in this painting, so there is considerably less contrast between the light and dark areas than in the previous pair of shorts. I began this little boy's cotton knit shirt with two layers, Blush Pink and Pink. I first covered all of the areas that are not highlights with Blush Pink, light to medium pressure. I then layered Pink only in the areas that will be darkest, using medium pressure.

2 Darks
I headed straight for the darkest areas in this step, layering Henna, Tuscan Red and Dark Umber. (You may have noticed by now that I use Dark Umber far more often than Dark Brown. Dark Umber is a much warmer, richer color and seems to be about one value darker than Dark Brown. When I really want to go dark, Dark Umber is always my choice.) I used heavy pressure on the darkest areas.

94

3 Deepest Darks
Still wanting to establish my dark values, I applied black, using heavy pressure, over the five darkest spots.

4 Midvalues
Once my darks were established, I was ready to move to the medium tones. I first layered Peach over much of the medium values. The yellow in the Peach will help warm up the subsequent pink layers. Next I applied Pink. I've done a lot of modeling at this stage, increasing my pressure where the values are darker, decreasing it where the values are lighter. Finally, I used Henna on top of the darker midtone areas.

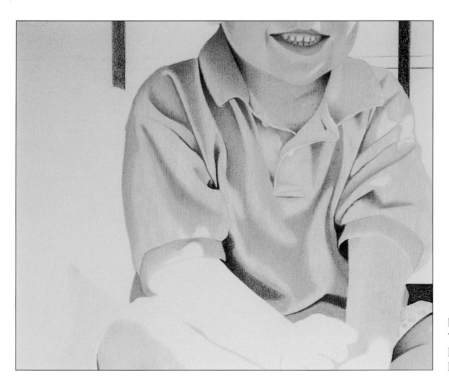

5 Final Midvalues
My last step was to bring all but the brightest highlights to a medium value. This was done easily by applying a light layer of Deco Pink, followed by a second light application of Blush Pink.

In this demonstration, you get to simultaneously see where I'm headed and how I got there.

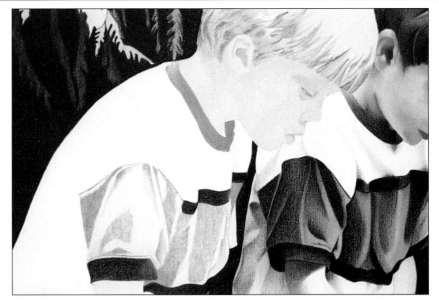

1 Establishing Darks and Wash
After first establishing the darks by layering the stripes with Indigo Blue, Dark Green and another layer of Indigo Blue, I "washed" the entire area with Deco Blue. Next, avoiding the highlights, I applied Peacock Green, varying my pressure.

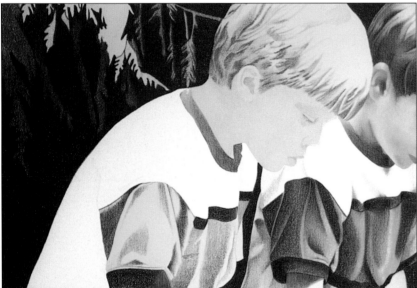

2 Introducing Indigo Blue
Indigo Blue was next. I used the full pressure range, from very light to quite heavy.

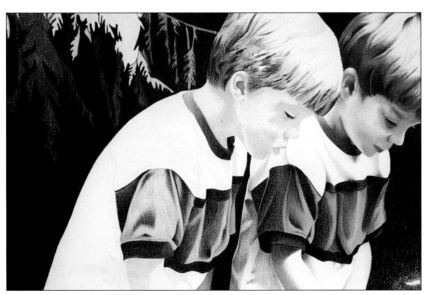

3 Shadow Areas
My next step was to darken and warm up the shadowed areas. There's a fair amount of yellow in Olive Green, so I used it to warm the shadows. That layer was followed by Dark Brown, then Peacock Green, with medium to heavy pressure. Finally, I added a light coat of Peacock Green to all of the lighter areas. Using Olive Green and Deco Aqua, my last step was to soften and blend the shadowed areas into the lighter areas, leaving only the lightest as highlights.

Patterns and Plaids Step by Step

Drawing patterns on fabric can be more difficult than painting solid fabric, but there's something a bit magical in watching flat lines and shapes turn into three-dimensional folds. Plaid fabric is one of the most complicated patterns to render; although it is time-consuming, I've always found the challenge stimulating. Can I really make it look like plaid that bends and buckles and folds? With plaids, I always start with the stripes that weave in and out. Only after establishing the actual plaid design do I lay in the background.

When working with a patterned fabric, my rule of thumb is simple: If the pattern is darker than the background, I start with the pattern. If the background is darker than the pattern, I first lay in the background, then worry about the pattern. There are actually two reasons here for starting with the darker value. The first is, of course, that once the dark values are in, it's easier to determine the rest of the values. The second is more one of necessity due to the nature of the medium itself. Say you have a pattern of tiny yellow daisies on a dark blue background and you begin with the daisies, spending a fair amount of time on the detail of these flowers. Next, you lay in the three to five layers it takes to darken the background fully. No matter how careful you are, inevitably the pencil "grime" from the dark blue layers will work into and smudge your cute little yellow daisies! And there's not a lot you can do about that, except lift the grime with "sticky stuff," then go back over each daisy! It saves time if you first fill in the dark background. You'll still need to lift grime off the paper in the empty daisy pattern before working on the daisies themselves, but it's far less frustrating than removing each one!

1 Defining the Pattern
My first step was to define the pattern of the plaid. I used Copenhagen Blue, Poppy Red and Deco Aqua, applied with light pressure, for the stripes. The darker stripe is also Copenhagen Blue, applied with heavy pressure. Since the left side of the shorts will be so deeply shadowed that the plaid pattern won't show, I haven't bothered to draw the stripes there.

2 Darkening Stripes and Beginning Wash
I darkened the stripes before moving on to the background area, using Crimson Red, Ultramarine and Indigo Blue. Next I began the background fabric with a "wash" of Celadon Green, followed by a layer of Olive Green. I varied my pressure with the Olive Green, increasing the pressure in the shadowed areas.

3 Shadows and Background
To add depth and warmth, I covered the entire background with Goldenrod, using heavy pressure. Next, I darkened the shadow areas with Indigo Blue, then covered all areas with a medium to heavy coat of Olive Green.

4 Foreground Pattern
With the background finished, I worked on the foreground pattern. First, I burnished white on the darker stripes that crossed over the white pattern. Next, using numerous French Greys from 10% to 50%, I shaded the pattern following the folds of the fabric.

Denim Step by Step

Denim is absolutely my favorite fabric to paint. The color is easy to achieve with various blues and greys. But what makes denim—particularly jeans—so much fun is the little puckers of the seam. By making small, irregular shapes in dark values between the seam and the seam stitching, you've got denim's "signature" just like that!

1 Establishing Darks
Before applying a wash, I wanted to establish a few of the darker areas, so I began with Blue Slate and Indigo Blue on the puckers and shadowed areas and Goldenrod followed by Burnt Ochre on the stitching.

2 Washes and Darkest Areas
After washes of Cloud Blue and Deco Blue, using light pressure, I applied black to the darkest areas.

3 Completing the Pants
My next step was to cover most of the fabric with 20% French Grey and Blue Slate. I used the side of my pencil for these layers to achieve a slightly rough texture. A coat of Deco Blue, applied with medium pressure, was used to blend all of the previous layers and to soften the puckered areas. Wasn't that easy?

Polished Fabric

This polished cotton doesn't quite have the shimmer of satin, but there is a bit of sheen to the fabric. I achieved this look by emphasizing the reflected color of the brick on her dress. Since the fabric is actually blue, the reddish orange brick reflects on the dress as a slightly purple tone. To capture this purplish hue, I used quite a bit of Deco Pink, Lilac and Greyed Lavender as final layers *on top of* the otherwise completed blue fabric.

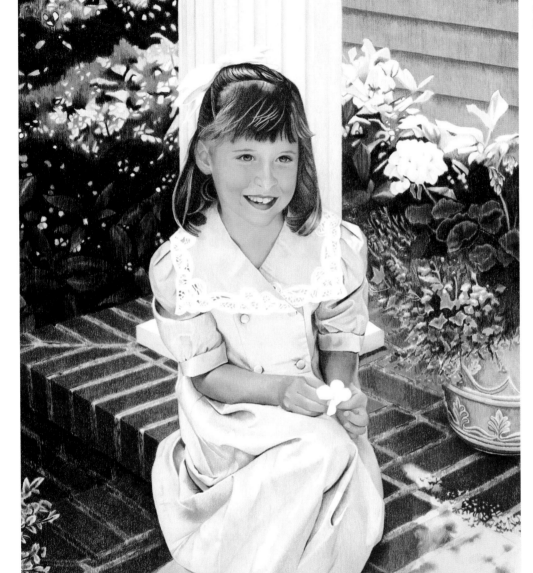

MEGAN
25″ × 22″ (62.5cm × 55cm)
Collection of Mark and
Debbie Madden

Knits Step by Step

You might think busy patterns and plaid are the hardest fabrics to represent, but I've always found knits to be the most difficult. The problem is in knowing how much detail to actually show. As with most art, I am more concerned in painting something that creates an illusion of the subject rather than actually painting each detail. In other words, I want to paint knit fabric without actually including every stitch of the knitting needle! I generally ignore most of the detail and let the detail of the ribbing around the sleeves and neckline do the work of representation.

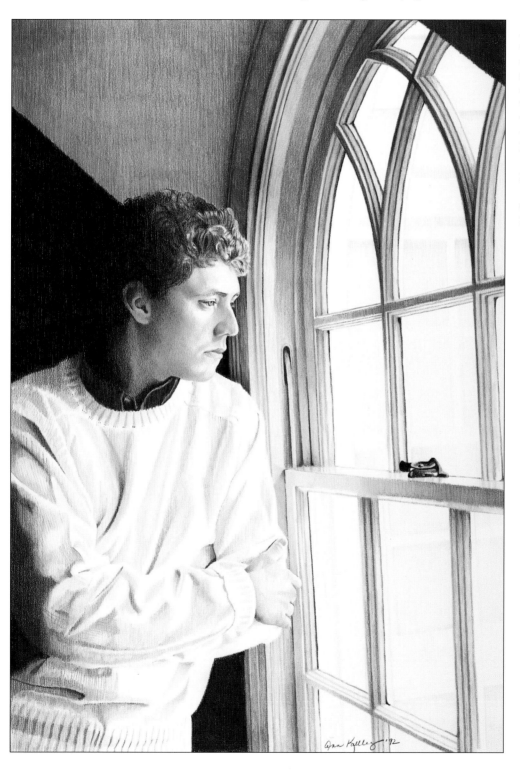

Most of the knit texture of Matt's sweater was accomplished in the ribbing areas. The rest of the sweater I rendered as if it were cotton fabric, with the addition of a few directional lines to suggest the knit pattern.

MATT
15″ × 20″ (37.5cm × 50cm)
Collection of Steve and Barb Spence

1 Defining Ribbing and Darks
I began this knit sweater by outlining the ribbing in black, using medium to heavy pressure. I wanted to lend a green undertone to this black sweater, so in the very darkest areas I first put a heavy coat of Dark Green, then black.

2 More Darks and Midvalues
Here I layered Dark Green followed by black in some of the other darkest areas. Then I used 50% French Grey in all but the highlighted areas. I began modeling with the grey, varying my pressure.

3 More Midvalues and Detail
Continuing the green undertone, I covered the grey with Celadon Green. Next, I used 90% Warm Grey to apply flecks between the ribbing and textured lines down a portion of the sweater.

4 Darkening Midvalues
I darkened many of the medium values with 70% French Grey. Next, I added Periwinkle Blue and Peacock Green to the darker midtone areas, followed by 90% French Grey. I then applied Jade Green to the highlight areas.

5 Shadow Areas
My last step was to further darken the shadowed areas with 90% French Grey. I used the side of my pencil over much of this area to produce a rougher "knit" feel.

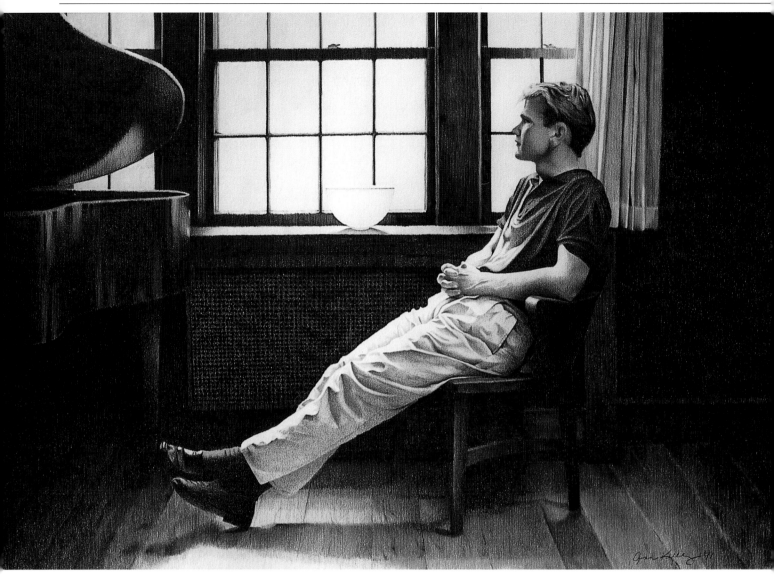

All of the other fabrics you see rendered in this book were achieved with my vertical line technique. This piece is an exception. More than anything, I felt this piece was about light. I really wanted to emphasize the reflected light on the subject's pants. I also wanted to be able to show extremely subtle gradations of color and value, so I chose to use the "Brillo pad" method to render these cotton trousers. Although vertical line would have worked, scumbling offers minute degrees of shading and nuance. It takes so much longer, but I think in this case the extra hours were worth it.

THE LISTENER
23″×16″ (57.5cm×40cm)
Collection of Dr. Thomas and Ellen Knox

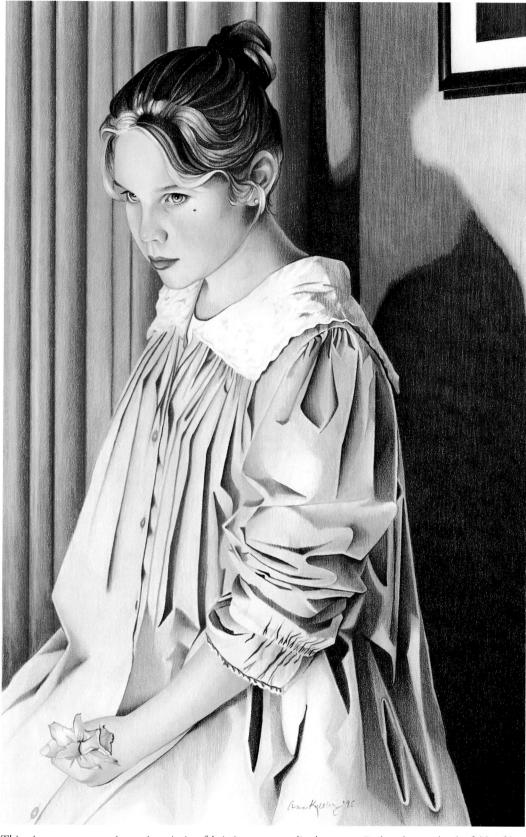

PRIVATE ROOM
11″ × 17″
(27.5cm × 42.5cm)
Collection of the artist

This piece was an experiment in painting fabric in a more stylized manner. Rather than make the folds of her gown soft and fluid, I deliberately chose to paint them in an angular, carved fashion. To achieve this effect, instead of softening the edges where the dark and lighter values met, I let the edges meet abruptly. I also straightened soft, curving lines, creating angular geometric lines.

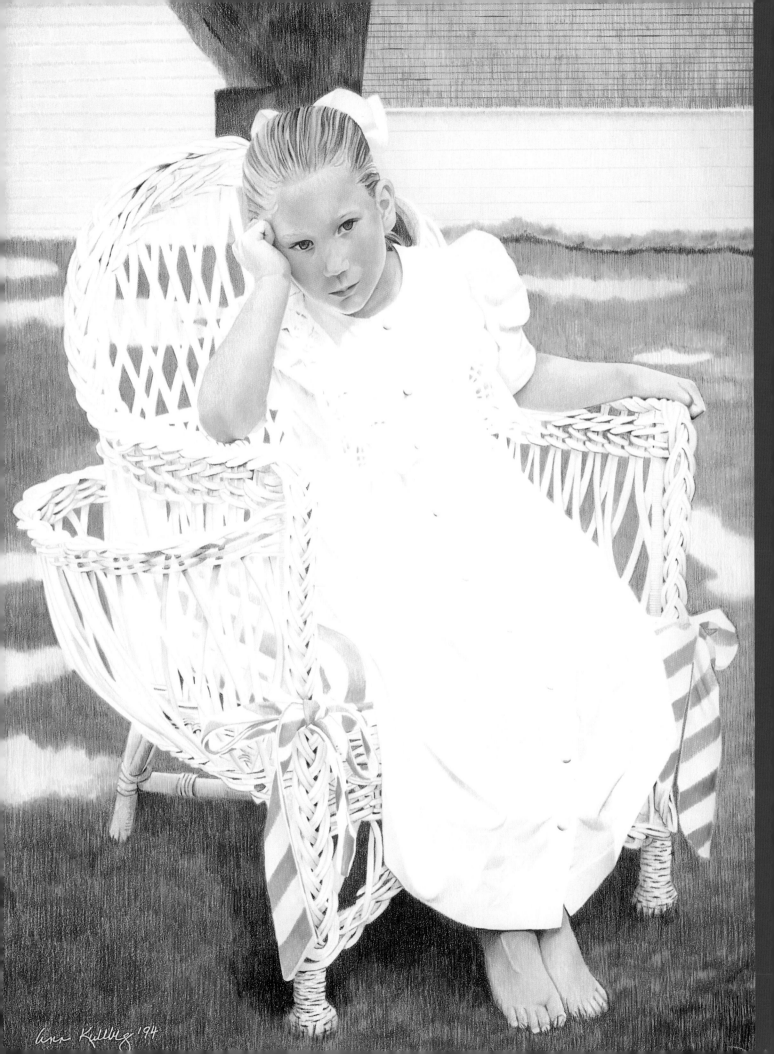

Putting It All Together

Facing a clean, new piece of paper can be both daunting and exciting. I remember very clearly being in grade school and finding nothing more satisfying than a stack of crisp, new sheets of white notebook paper and a freshly sharpened no. 2 pencil. I loved feeling that here was something brand new—pristine—and it was in my power to place whatever I wanted on this page, to transform it from nothing into something. I guess I haven't really come very far since sixth grade; I've just changed the materials a bit. Now it's a crisp, new, white sheet of Stonehenge and eighty or so freshly sharpened colored pencils.

MARGARET
22″ × 17″ (55cm × 42.5cm)
Collection of Jim and Kelly Johnson

The Painting Sequence

When I first started painting portraits, I was eager to get to the face. Although I enjoy drawing the figure, little bare feet and how the light plays on fabric, the real deal is the face. The face connects me to the portrait. So naturally I was impatient to get to my favorite part and have someone look back at me from my drawing. Many years ago, I read that Andrew Wyeth first painted an "environment" for his portraits of Helga before moving on to paint her figure and face. I remember thinking I could never wait that long. Funny how things change.

The longer I paint portraits, the later in the sequence the face comes, and it turns out there are at least two really good reasons for this: First of all, if the background area is darker than the face, you absolutely should paint the background first. Why? Let's say you finish your face first. The face is perfect, the values are perfect against all that white background, and you're very, very pleased. Next, you put in all that dark background behind your subject and, alas, your perfect face now looks as pale as a ghost in front of all that dark. You have to go back over the face you loved to deepen the values,

and you know it will never be the same! Spare yourself the agony. Paint the background first.

The second reason is possibly a little "artsy-fartsy," but I believe it. While you are creating the background (what I call the "support"), a part of you is observing, taking in and solving problems about your subject. By the time you finish the support for your subject, you've spent anywhere from twenty to fifty hours looking at this person's image on the reference photos. Even if it's subconscious, I'm convinced time helps you know your subject. By the time you do start on the face, you are really ready.

The last tip I have for the sequence in which you paint your portraits is a subjective one: I always leave what is most difficult until the end. I know a lot of artists who do beautiful work and who start with the most difficult part. I've heard the arguments for doing it this way, the most common being to get the hard part over with first, because if you wait until you've already invested 60 to 120 hours in the piece and *then* you mess up, all that time is wasted. I see the point. My problem is that if I had to start with

the hard part, I would never get started!

My style is to start with what I already know I can do and gradually work into shakier ground. I assume this is just because I am, if nothing else, a true procrastinator. But I actually have a reason for this method, too. What I've found is as I start to work on a piece, inevitably I do something I just love: a certain highlight on the foreground, a bit of shading on the wall in the background, a bit of wood grain that looks so real I feel I should dust it once a week. Always there's a bit of the painting that "sings." I fall in love with that little part. And now that I love this part of the painting, I *owe* it to that little part to do the best I possibly can on the rest of the painting, including that difficult area I'm not yet sure how to do!

This method also gives you the advantage of time. While spending all those hours on the rest of the portrait, I have no doubt that a certain part of you is solving the problem areas as you work along. Many times I've found that once I finally do get to that difficult area, the problem seems to have been solved and I know just what to do.

Painting Margaux Step by Step

When looking at all the possibilities from the photo shoot for Margaux, I was instantly drawn to this image. I loved her rather serious but contented expression and the sweet way her feet rested comfortably and naturally on the patio floor. I knew the dark brick and background would provide a lovely backdrop for her light dress and really show off her face.

Reference photo

1 Dark Background

I wanted to fill this dark background in quickly, so except for the closer leaves, I covered this area with four quick layers: black, Dark Umber, Dark Green and more black. I'm not sure yet what I'm going to do with the area just to the right of the leaves, so I'll wait and see what happens!

2 Washes

It looks like a lot happened in this step, but I've simply laid "washes" over most of the foreground and background. The colors I used for these first layers, beginning with the patio floor under Margaux's feet and moving clockwise, were as follows:

Patio. Indigo Blue, medium pressure.

Shaded brick. Mineral Orange, light pressure.

Mortar. 30% French Grey, light pressure.

Space below the far brick. Black, medium pressure.

Far brick. Dark Brown, both light and medium pressure, with black on top representing the mortar.

Leaves. Celadon Green, medium pressure.

Top of the brick. Light Peach, medium pressure.

3 Bricks

I knew I would be adding a lot of orangish browns to the brick later on, so to make sure it wouldn't be too orange and to give it a bit of faded, old-brick look, my second layer was Blush Pink. I started to do some modeling at this point by varying the pressure from medium to heavy. Next, I layered 50% French Grey over the mortar, varying my pressure throughout to get a rough, uneven look. I gave the area below the far brick a layer of Dark Umber, heavily applied, and covered the darker brick with a heavy coat of Tuscan Red to warm it up and make sure it has a different undertone than the dark green foliage background.

4 Patio Floor and Mortar

Getting these next darks in really made the painting start to "sing" for me. This deep contrast is what I was after, and you can see it doesn't take much to achieve! I've layered 70% Cool Grey over the upper half of the patio floor, followed by another layer of Indigo Blue and finally black, all applied with heavy pressure. A layer of black followed by Indigo Blue, both at medium pressure, finished up the bottom half of the patio floor. Lots of 70% French Grey and black over the mortar helped bring out the bricks. I used a dull point and choppy, widely spaced strokes and varied pressure to keep the mortar from looking smooth. I also added Dark Umber and black in the area below the far brick.

5 Bricks and Leaves

Next I added Clay Rose over parts of the brick fronts, being careful to note where the color looked uneven. Using Olive Green, I layered over the leaves that seem farthest back and added Apple Green to some of the others. Those I've left alone will be the lightest all the way to the end.

6 Darkening Bricks and Leaves

I further built up the color on the front of the brick with Pumpkin Orange, Burnt Ochre and a little of both Sienna Brown and Terra Cotta. I wanted some of the leaves to recede quite far into the background, so I concentrated on darkening these with Dark Green and some Sepia. Sepia is a brown with a lot of green undertones, so it works well here.

7 Finishing the Bricks

I finished the front of the brick by darkening the area shadowed by Margaux's dress with Dark Brown and Dark Umber. This made the dress come forward and the brick recede, adding depth to the portrait. Now that the darker bricks are finished, I can quickly finish the upper bricks using Peach, Mineral Orange and some 50% French Grey.

8 Hair

I now felt there was enough "support" established to begin working on Margaux, so I started with her hair since it is very dark. I washed the dark shapes with Dark Brown, using medium pressure, followed by Dark Umber in a few places that will end up especially dark. The lighter half was washed with Jasmine, again using medium pressure.

9 Building Up Darks in Hair
Now I've built up the darker half with Terra Cotta, then Tuscan Red, both with medium to heavy pressure. Since Margaux's hair and the background behind her are nearly equally dark, I used the red undertone to keep a contrast between her hair and the green undertone of the background. In the darkest areas, I've applied black, followed by a heavy coat of Dark Umber. I've also started dividing the lighter hair with a little Goldenrod, Burnt Ochre and Sienna Brown.

10 More Hair Darks
Here I've covered the darker area with very heavily applied Dark Umber. I've divided the lighter area further, using Goldenrod, Light Umber and Dark Brown.

11 Finishing the Hair Darks
The last step on the darker side was a final layer of black, using medium to heavy pressure. I've warmed up and darkened the lighter hair with more Burnt Ochre and a bit of Terra Cotta and Sienna Brown.

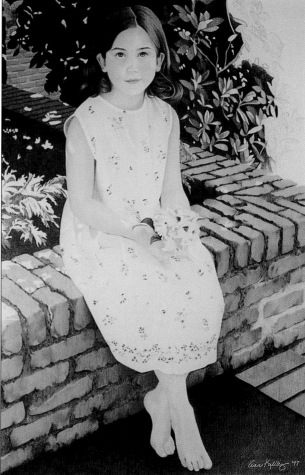

12 Completing the Hair

By going into the highlights with all of the colors already used on the hair and darkening up the lighter side a bit, I finished Margaux's hair. The next step will be the face; knowing the lightness of the leaves to the right of her will distract me, I darken these further with Grass Green, Dark Green and Olive Green.

13 Completing Washes and Starting the Eyes

It looks like I've taken a big jump, but there's not much more here than washes. Since the pattern of her dress is darker than the surrounding cloth, I began by completing the pattern. I then colored the fabric with Cream, using medium pressure, followed by 10% French Grey, also using medium pressure. Finally, I added a bit of 20% and 30% French Grey in some of the folds and shadowed areas, followed by a layer of Jasmine to warm up these shadows.

Next I gave all of her skin the first two washes of Cream and Light Peach, lightly applied. I then used Deco Pink, Jasmine and Peach in very light washes. Finally, I began some modeling with Peach, using very light pressure.

Now I was finally ready to take the leap with the bush. I started with washes of Dark Green, followed by Sepia, applied with medium pressure.

Going back to the face, after the first two washes of Cream and Light Peach, I worked on Margaux's eyes. I used Goldenrod as the undercoat for her iris, followed by Burnt Ochre, Sienna Brown and Dark Brown. These are just tiny little semilayers, using only medium pressure. Only the pupil (painted with Indigo Blue and black) gets heavy pressure. The iris is rimmed with Dark Umber. Next, I worked on her skin, adding a very light layer of Deco Pink then Jasmine to the washes. I began modeling with Peach, leaving some areas alone and only covering those areas that will be darker. Every layer I apply to the face is done with a very sharp point and *extremely* light pressure, with the strokes very close together. I began her mouth with Terra Cotta on the line between her lips, then a layer of Peach, followed by Blush Pink, then Mineral Orange. Finally, I worked on her eyebrows, starting with Light Umber and moving to Dark Brown.

14 Completing the Foliage

I've now darkened and basically completed all of the foliage with dark greens and browns. I often find these unfinished areas distract me from concentrating on the face until they are completed.

15 Building Skin Tones

Here I've continued to build skin tones, going up the skin tone value range. I carefully added Yellow Ochre and Blush Pink to her face. Her neck, arms and feet received those layers, as well as Burnt Ochre, Pink Rose, Rosy Beige and a small amount of Terra Cotta along the left side of her arm. I also added Clay Rose and Light Umber to the shadowed side of her feet, completing both arms and feet.

16 Completing the Face

I slowly built up Margaux's face with further layers of color, always using a very light touch. I added some Mineral Orange to her cheeks, forehead and under her eyes, then went back to Deco Pink and Jasmine over these same areas to blend them. Just under her eyes, I carefully layered Pink Rose and Rosy Beige, followed by Peach. This hint of greyish tones helps to build that shadow while giving it a bit of a translucent quality. Blush Pink followed by hints of Pale Vermillion and Pumpkin Orange finished the left side of her face. I darkened her lips a bit with Pink, Pumpkin Orange and just a touch of Scarlet Lake, then darkened the line between her lips again with Terra Cotta. The last step was to soften the edges where her hair and face meet. If you don't do this, the hair can look pasted on. Choosing skin tones that are between the values of the hair and the skin (in this case, Rosy Beige and Light Umber) softens and blends the two areas. I also added a bit of cast shadow from her hair at the top of her forehead and to the left with Goldenrod, Mineral Orange, Burnt Ochre, Terra Cotta and Dark Brown.

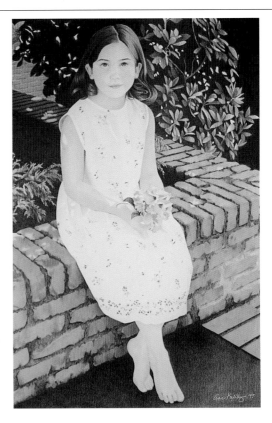

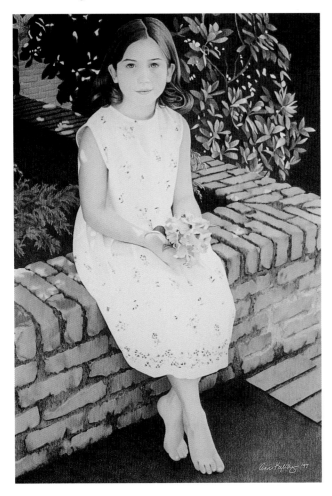

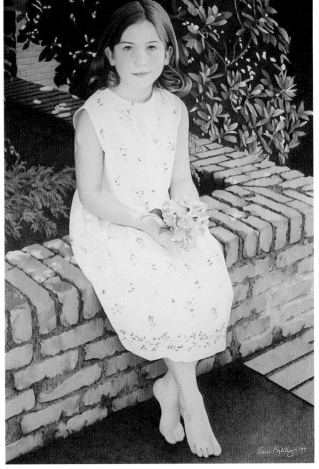

17 Final Touch

My last step was to darken her eyebrows with a bit of Dark Umber and black, then darken the line between her lips one last time with a bit of Dark Umber. From a blank piece of Stonehenge came Margaux—ready to frame, to enjoy and to be passed on to her grandchildren some day!

HINT

You don't want to just "paste" eyebrows onto the face. Make sure you have several layers of skin tones down first (we do have skin under our eyebrows!) and that you soften the edges of the brow with lighter shades of brown to indicate the very small, fine hairs that start the brow.

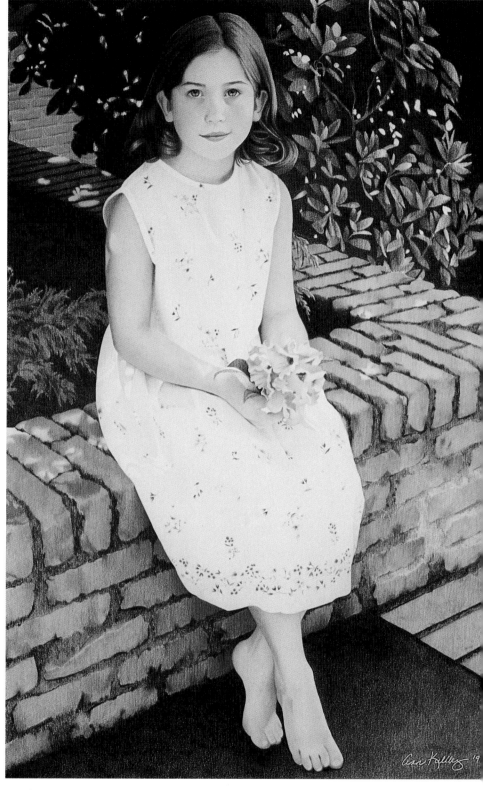

MARGAUX
20″ × 25″ (50cm × 62.5cm)

Painting Katie and John Step by Step

Katie and John Bradley were two of the most likable children I've met during my years as a commissioned portrait artist. Not only were they beautiful, sweet children and perfect models, but after our photo shoot they were also kind enough to show me their pet rats, each on its own little leash! In the following twenty-one steps, I'll be giving less written direction than for Margaux. I'm mainly concerned here in showing you, in pictures, the sequence of how a portrait unfolds.

I was lucky enough to get one shot of the two kids that was basically what I was after. The only changes I needed to make were to open John's eyes a bit and to simplify the background.

1 Washing in Support
As always, I wanted "support" for these two beautiful children before beginning on their faces, so I started the wall behind John's head with Jasmine, Peach and Yellow Ochre.

2 Introducing Darker Value
I introduced Celadon Green on the wall.

3 **Building Background in Layers**
I've added Olive Green and Light Umber to the wall and begun the dark molding with Tuscan Red.

4 **Completing Background**
I've completed the molding with Dark Umber, then black.

5 **Starting Middle Ground**
I began the red velvet couch with Poppy Red, except those areas that are so shadowed they are flat. Those areas I covered with Dark Umber. You can see a couple spots here where I've "gone ahead"— I sometimes like to try several layers in a little spot to see where I'm headed. I left the highlighted area alone.

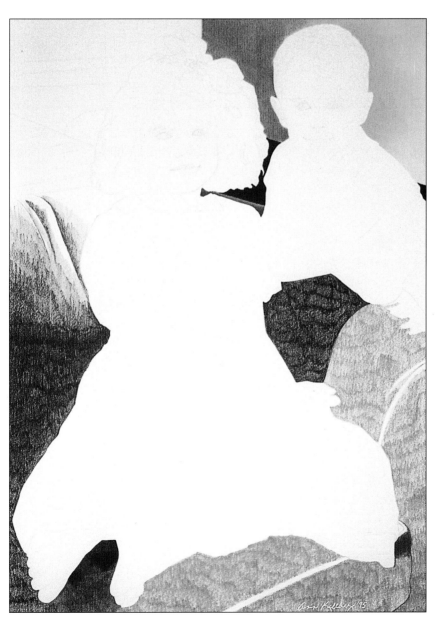

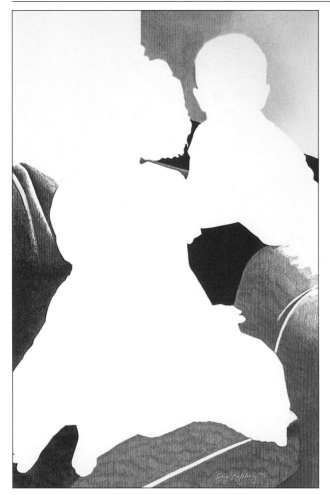

6 Building Middle Ground in Layers

I've layered the front of the sofa with heavy coats of Scarlet Lake and Crimson Red. The darkest area was covered with Tuscan Red, Dark Umber and black. The area to the left got layers of Terra Cotta, Crimson Red and Dark Brown.

7 Middle Ground

I built up the sofa arm with layers of browns and black, still not touching the highlighted areas.

8 Middle Ground

The back of the sofa is covered with more layers of browns and black. I layered the sofa cushion with browns, more reds and black, leaving the piping lighter red. To make this look like piping and not just a flat strip, I put a strong cast shadow below it and darkened the bottom edge of the piping slightly.

9 Middle Ground
Finally, I worked into the highlighted areas with Poppy Red.

10 Middle Ground
Next, I layered heavily with Scarlet Lake and Crimson Red.

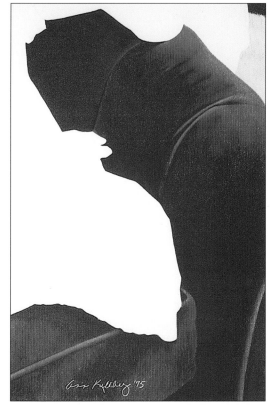

11 Finishing Middle Ground
Last, I blended the light and dark areas by pushing the browns and some black higher up on the sofa arm.

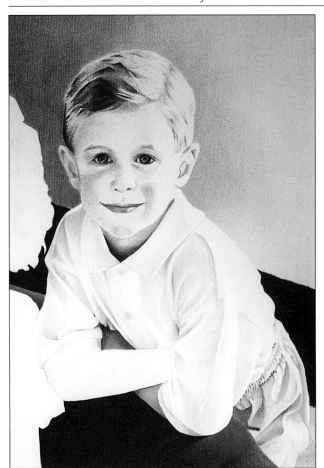

12 John's Hair and Face

With the "support" completed, I was ready to begin on John's face. I started by outlining his features with Peach, then began working on his eyes. I then applied a "wash" of Jasmine to his hair. (You can see the whole progression of John's face on pages 70–73.) At this stage, I've completed John's hair and am about halfway through the skin tones on his face.

13 Starting Katie's Dress

John is now completed, so I started Katie's dress. I began with a wash of Cloud Blue, then used many shades of increasingly darker blues and greys to render her dress.

14 Eyelet Lace

The little eyelet lace on Katie's blouse might look like it would be difficult, but actually, nothing could be easier. Simply make little circles of dark skin tones on the white blouse and you've got eyelet lace.

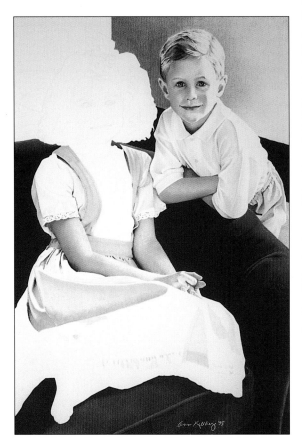

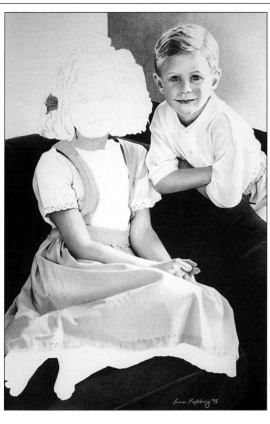

15 **Katie's Hair and Neck**
I finished the dress and began Katie's hair by outlining the areas that will be slightly lighter than the surrounding hair. I then built up several layers of skin tones on her neck.

16 **Working the Darker Features**
After covering all but the highlights with Dark Umber, I outlined her features with Peach, then worked on the darker areas of her face: her eyes, nostrils and mouth.

17 **Katie's Hair**
I've now layered her hair with heavy coats of black and Dark Umber.

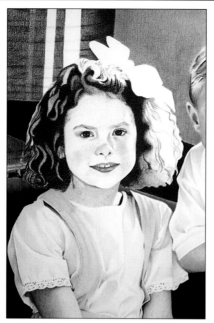

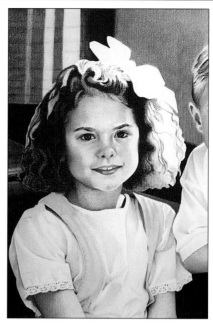

18 **Background, Eyes and Highlights**
I was finding the white space behind Katie distracting, so my next step was to fill in this area. I moved on to finish her eyes, then used Light Umber for the highlights on the left side of her hair as well as for the wavy lines on the right side.

19 **Mouth and Skin Tones**
Here I finished Katie's mouth with various oranges and reds, then began her skin tones with Cream, Light Peach, Jasmine, Deco Pink and some Blush Pink. I also covered her eyebrows with a little Yellow Ochre.

20 **Building the Skin Tones**
I continued to layer colors from the skin tone value range on Katie's face, going as dark as Tuscan Red and Dark Umber on small sections of the shadowed side of her face and neck.

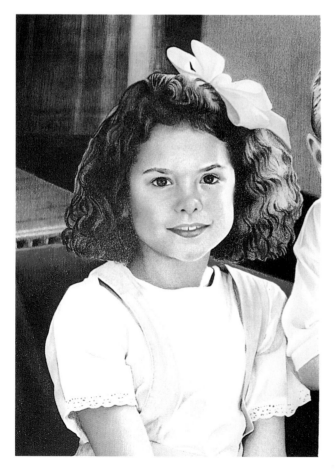

21 **Saving the Hard Part for Last**
The last step, and the one I feared would be most difficult, was the highlighted section of Katie's hair. By working in a curving pattern of dark to light to dark again and adding a few reflective colors, I think I managed to pull off Katie's highlighted wavy hair.

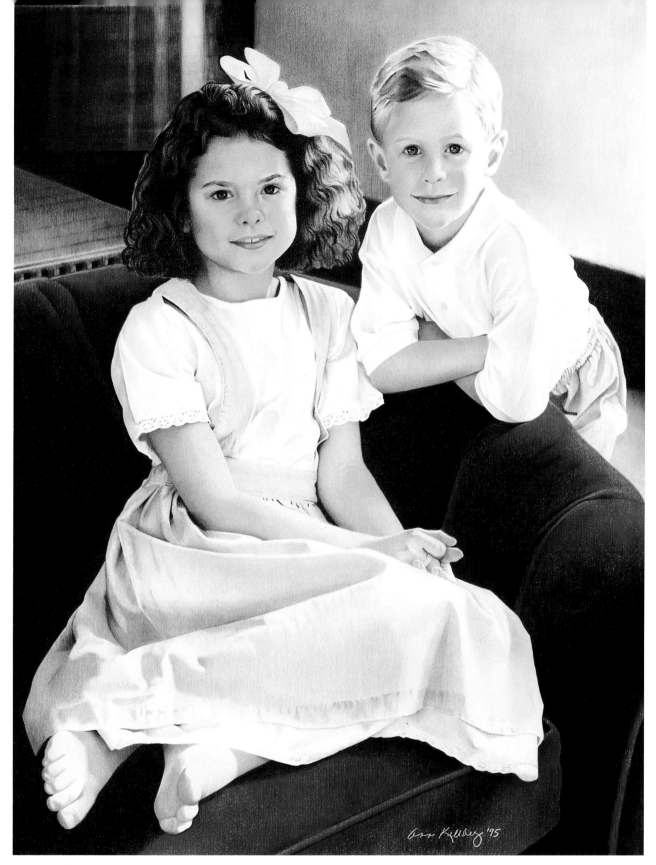

KATIE AND JOHN
16″×21″ (40cm×52.5cm)
Collection of John and Kim Bradley

The Portrait Business

Painting portraits for your own pleasure and painting portrait commissions for a living are two entirely different beasts. I've given dozens of portrait workshops around the country and found that many of you are interested in knowing exactly how those beasts differ. Since I've basically been supporting myself with portrait commissions for the past six years, and have learned a lot the hard way, I decided to include this section on the business side of art. If I can do anything to make it easier for you, I'm glad to help.

I should begin by saying that I never set out to be a portrait artist. I loved drawing people and drew almost nothing else, but the idea that someone might want to commission me for *anything* didn't even occur to me. One fateful day, out of the blue, I received a phone call from a woman who'd seen my work in an Oregon gallery and wanted to know if I accepted commissions. I promptly assured her I did. (Of course, I'd never taken a commission in my life!) I felt that if my work pleased her, I might receive another commission or two from her friends.

Sure enough, about three weeks after I completed that first commission, I received a call from a friend of my first client asking if I would paint a portrait of her daughter from an existing photograph. I went to her home, looked through photo albums, chose one I felt I could work from, and a few weeks later delivered a framed 20″ × 26″ (50cm × 65cm) portrait in exchange for seven hundred dollars.

In a matter of days, the woman's sister called, asking me to do her daughter's portrait. This time I shot my own photos, and within two weeks of delivering that portrait, I had *thirteen* calls for new commissions! I was a portrait artist. Just like that!

In the years since that first commission, I've developed a system for the entire portrait process, from first con-

tact to finished product. Following is an outline of that process.

INITIAL CONTACT

Nearly all my new clients come to me via word of mouth. Consequently, my first contact with most clients is usually a phone call I receive after they've seen one of my portraits. Because I prefer not to discuss prices over the phone, I immediately offer to send them an information packet that includes:

- four or five professionally photographed samples of my work
- my biography
- a letter explaining the portrait procedure
- a price list

I then take the caller's name, phone number, address, children's names and ages, and note the date they called. I file this in my "Prospects" file.

For the last year or two, I've had such a long list of backed-up commissions that I now have a waiting list. So, before we hang up, I mention that I do have a waiting list and am backed up a year (or six months, or whatever the case may be) and that a deposit of four hundred dollars will hold the client's place in line, as well as hold the price for one full year. This puts a bit of subtle pressure on the prospective client and adds some perceived value to my work.

If I don't hear from the prospective client within a couple of weeks, I call to ask if she's received the information. If she's decided to go ahead with a commission, I then fill out a contract (detailed later), file it in my "New Contracts" folder, remind her to send me the holding deposit, discuss when we might take pictures, let her know—based on my workload—when she might expect the finished portrait, and tell her when I will next contact her.

PHOTO SHOOT

A few weeks before the photo shoot, I call the client and talk about the photographing procedure. We discuss what the child(ren) might wear, any special items (pet, favorite teddy bear, etc.) that might be included in the portrait, whether the client wants an indoor or outdoor setting for the portrait, the size she is considering and the time to allow for the shoot. I tell her to schedule about an hour in total, with about twenty minutes of that being the actual photographing.

On the day of the shoot, I first ask if she has a particular wall in mind for the portrait, and whether it matters if the piece is vertical or horizontal. Once those details are established, I present the contract and ask the client to read it while I scope out possible photo locations. I then take my camera and walk

around the home to find three good areas where I can place the child for the photos. For example, I might choose the front step with its lovely flowerpots as one area, a well-lit bay window as a second possibility and the backyard swing set as a third. I do this alone so I can pay attention to background details. By the time I've chosen the locations, the client has generally read and signed the contract.

The next step is to take the child to the areas I've chosen for photographs. Parents aren't invited to this part of the procedure! I've found that when parents are nearby, the child gets nervous and freezes, and Mom is generally fussing over unimportant details. When I get the kid alone, things go *much* more smoothly and I get more natural expressions. I talk to the child constantly while shooting. I want to get him animated and make him forget he's being photographed.

Good photographs are key to a good portrait. I have a good Pentax camera that does everything for me automatically, but the key is to take tons of photos. I take 100 shots of one subject and 150 to 200 if there are two or more children. Take many, many shots in the same location, from the same angle and with the same lighting.

For example, say Trevor is sitting on the front step next to a flowerpot. I stand in one spot and take a full roll without moving. Trevor may move some—I may ask him to turn his head a little, or put his feet together or look at something in particular—but I stay in the same spot, clicking away. (I actually give very little direction. Generally, I simply ask the child to sit or stand in a particular spot, then let him get comfortable. I get more natural poses that way.) I may use the zoom a few times to get a closer shot of his face, but other than that, I stay put.

If you have twenty-four shots of Trevor on the step with consistent camera angle and lighting, you can easily combine elements from different shots to get one perfect pose. For instance, you could use Trevor's pose from shot A, his expression from shot B and his hands from shot C, without the huge headache of trying to correct for differences in perspective and light.

After a roll or two in one spot, we move on to the second and third locations and we're finished!

Once the pictures are taken, I wrap up the shoot by collecting a check for 35 percent of the portrait total, filling in the appropriate information on the contract and giving the client her copy. I tell her that sometime within the next three weeks I will let her know how the photos turned out, and I thank the child for being such a great sport.

CHOOSING THE REFERENCE PHOTOS

Once my photos are back, I first sort them by location. I then run through them very quickly, making two piles for each location. The first pile is for "possible" shots and the second is for "not a chance" shots. At this stage I'm looking for three elements: composition, pose and expression. Of a hundred shots taken, I would say I generally end up with four to ten shots in each of the "possible" piles.

Next, I go through the possible shots very slowly to narrow them down to one or two of the best in each location. From experience, I've learned there is rarely one perfect shot, so if there is an element in one of the best shots that could be better, I go back through both the "possible" and "not a chance" piles, looking for a better shot of that particular element. For instance, if Trevor's pose and expression are perfect in shot A but his hands are a bit awkward, I go through all the other photos taken in that location to find a more pleasing shot of his hands. What I will *not* do is choose an element from photos taken at a different location. If there are absolutely no pictures I can use to substitute, I eliminate all of the pictures from that location.

About 20 percent of the time, even with one hundred or more shots, I don't have anything great to work from. When that happens, we schedule a retake.

Once I've narrowed the choices down to one or two from each location, I'm ready to show these to the client. Together we decide which of the best I will work from. If the client is more than two hundred miles from my home, I send duplicate photos along with notes for each one and ask her to call me once the photos arrive. Over the phone, we both look at the photos together and make the final choices. At this time, I let her know when to expect delivery of the portrait.

DELIVERY

About a week or so before completion, I call the client to let her know we're getting close and to schedule a delivery time. At this time, I do a little "schmoozing." Portraits are a big deal. The client is spending a lot of money and has a lot invested emotionally, since it is really a "once in a lifetime" sort of venture. The client is worried she won't like my work, and no matter how pleased I am with what I've done, I'm also worried she won't like it! So I lay a little groundwork at this point to ease the delivery process a bit.

I tell the client not to expect to fall in love with the portrait instantly. I'm hoping this might help her be "pleasantly surprised" with the portrait. I mention that about a third of the time, clients are immediately pleased, but that generally it takes a little while for the portrait to grow on them. For months, the clients have had images in their heads of what the portraits might look like; those images can't help but be different from what I'm about to deliver. I firmly believe that most of the time, a "relationship" must be formed between the client and the portrait, and this usually takes a little time. Many years ago, I delivered two portraits to a woman who really did not

seem particularly pleased. Three days later, she called to apologize and tell me she loved the portraits. She said, "My husband and I were talking last night and said that if we had a fire, we don't know which we'd save first: the portraits or the boys!" Needless to say, that made my day!

Once the portrait is complete, I have it photographed, then frame and deliver it to the client's home. "Unveiling" the portrait really can be nerve-racking and is the aspect of being a portrait artist I least care for. But more times than not, I get a hug and occasionally a few tears from a happy client. I then collect the balance, remind the client to recommend me to all her friends and off I go to start the next one!

CONTRACTS

For years I worked without any sort of written contract. Then I ran smack dab into the "Unpleasable Client!" After completing a portrait and having it rejected, reworking the portrait and having that rejected, completing a second portrait and having her say she liked the first one better, I learned a valuable lesson. One word: contract. Mine is simple. Basically, I wanted documentation that stated I would do my best possible work and, in return, expected compensation at the time of delivery. I also wanted documentation of the total cost of the portrait, any deposits paid and the balance due. I have the contracts printed as two-part documents. I give the client the top white copy and I keep the bottom yellow copy for my records.

PRICING

Pricing your work can really be difficult. I developed my own system after reading an especially helpful article by Bernard Poulin years ago in *The Artist's Magazine*. It's based on square inches, which seems to be one of the fairer systems for both artist and client.

First, set the minimum amount you're willing to accept for a portrait commission. With every commission there are certain elements that are required, regardless of the size of the portrait or the number of subjects being portrayed, such as promotional material, photography time, film, sketches, framing and travel time. Taking all that work into consideration, decide on a base price. Let's say you decide your base price is $500.

Now, choose the smallest format you are willing to paint. I chose $15'' \times 20''$ (37.5cm $\times 50$cm) as my smallest format. Your base price is what you charge for one subject in this smallest size.

Next, decide what you want to charge per square inch over and above your base price. For simplicity's sake, let's say you decide to charge $1 per square inch. Your next step is to make a list of sizes you want to offer. Now do the math. $15'' \times 20''$ is 300 square inches; $20'' \times 20''$ is 400 square inches. The difference is 100 square inches, so at $1 per square inch, a $20'' \times 20''$ portrait would add $100 to your base price, bringing it to $600. The beauty of this method is that it allows for odd sizes. If the client wants a $15'' \times 30''$, you can easily calculate the difference in square inches and come to a fair price.

Finally, decide what percentage you want to add to the total for each additional subject included in the portrait. For the first three years I added 25 percent, but I have changed that to 40 percent and am still low. Most portrait artists charge 50 percent and a few add 75. In addition, I add 25 percent for large animals (such as horses) and 10 percent for smaller animals. All of this information is on the price sheet I send to my prospective client.

One more word about pricing. When you're first starting out, you almost have to underprice your work. It's unfortunate, but true. In my first couple of years of working as a portrait artist, I averaged less than $5 per hour once everything was taken into account. In my opinion, it's far better to do twenty portraits (in other words, twenty pieces of advertising) for next to nothing than to do one (only a single piece of advertising) and receive what it's worth. Portrait work is almost entirely based on word of mouth. The more people who see your work, the more work you'll have. Also, the whole time you are working for so little, at least you are honing your skills and getting ready for the big time!

You do need to gradually increase your prices, though. On the bottom of my price sheet, I always state "the following prices are good through" such and such a date. At the beginning, I raised the prices by 10 percent every six months. That way, the increase was gradual but steady, and all potential clients knew in advance that the prices would increase if they didn't act now. The last two years I've raised the prices only once a year but have kept the increase at 10 percent.

There's a lot more to the business of portraiture—probably enough for another whole book. Hopefully, I've given you enough information here to either get you started on your own portrait career or help the one you've already begun.

Blunders and Mishaps

I've shown you a whole book full of portraits that went well, but I'd be leaving out some of my best stories if I close without letting you know a bit of what *hasn't* gone so well!

The Sin of Omission. Early in my art career, I did a painting of a *maiko-san* (a Japanese geisha-in-training). The maiko-san had all sorts of flowers and other ornamentation fastened in her hair. I had the picture framed and was hoping to sell it at a silent auction a good friend of mine was throwing. As I hung the piece in preparation for the auction, I noticed that I'd totally neglected to fill in a few of the silver beads that adorned one of the combs in the maiko-san's hair. The little graphite circles were there, but no colored pencil! I was so desperately broke that I hated the thought of not being able to offer the painting for sale, but there was no time to fix it.

The piece sold that night to a good friend of the hostess. I'd admitted my omission to her, and she simply could not resist telling the new owner there was a tiny flaw in the piece, to see if he could find it. Thankfully, he got a kick out of it, and although it took him a few months, he finally did find the bare beads. I now thoroughly check a painting for any missed spots *before* framing!

Scar Tissue. This disaster happened back when my "studio" was tucked behind the couch in the family room. I was particularly ambitious one morning and had already started working before Katie, my daughter, left for school. She was busy making her own art with fluorescent puff paint on sheets of card stock. Before she went out the door, she handed me one of her still-wet paintings to admire. I then laid the fresh painting on the little table next to me.

I was working on a nearly completed painting of two darling little girls. It was, thank goodness, not a portrait commission, but the piece was going exceptionally well, and after putting eighty hours into it, I had only a few hours to go before completion. My reference photo was on the drawing table, and at one point, I moved it out of the way by absentmindedly placing it on top of Katie's wet painting. A few minutes later, I placed the photo right square on top of the part of the painting that was still bare paper. When I moved the reference photo, I found—to my utter horror—the area that was soon to be a little hand was covered with blobs of screamingly bright fluorescent paint!

I spent the next several hours applying similar blobs of paint to scrap pieces of Stonehenge, letting them dry, then practicing scraping the paint off with a razor blade. I finally managed to remove all of the visible acrylic paint and was able to apply colored pencil over it, but there were spots where the acrylic had seeped into the grain of the paper, causing the pencil to skip. In the end, no one else could see anything wrong, but I always felt that little hand looked a bit like it was covered with scar tissue!

Danny Boy. I've saved the worst for last. I am in no way a "country girl." To me, a horse is a horse is a horse. I had accepted a commission from a man to paint Danny, his wife's most beloved stallion, as a birthday gift to her. In addition to Danny, they owned eight mares. We'd decided that a composition with Danny as the centerpiece and a few of the mares behind him would really show Danny off. The day I went to their farm to take pictures, they first brought the mares out into the pasture and I took rolls and rolls of film as they wandered and galloped around. Next came Danny, and I again took many rolls of film of Danny looking handsome and proud.

With portrait commissions, I always OK the reference shots with the client before beginning the portrait, but this was a horse, and I was confident that everyone would be happy with my selections. I worked hard on the piece, spending a great deal of time making Danny look sleek and powerful and beautiful as he galloped across the center of the painting with his tail flying, his head high, his muscles gleaming.

I was meeting the clients at my parents' home for delivery. Before Danny's owners arrived, we carefully hung the painting on a wall so it would really look nice when they first saw it. The doorbell rang, and in they came, the wife making a beeline for the painting. I waited for the expected cry of delight. She stood a foot in front of the painting and put her hands over her mouth. I waited. She stood there for at least four minutes without moving a hair. I was beginning to feel a bit anxious. Finally, she removed her hands from her mouth, and in almost a whisper said, "Where's Danny?"

Ever been utterly, totally, magnificently embarrassed? The proud "Danny" in the center of the painting was none other than "Penny," who, while to me looked remarkably like Danny, was actually a *mare* and a lame one to boot!

The clients were very gracious. I gave them the painting, along with profuse apologies, then later did a close-up portrait of Danny alone. This time, they provided the photograph! Needless to say, I have begun no commission since without client approval on all reference shots.

So I've learned a few things over the past ten years, and I'm sure there are more near disasters coming in the next ten. But all in all, the work is rewarding, you can't beat the commute and, if nothing else, the mishaps make great stories for years to come. I wish you fewer disasters, great luck and years of colored pencil pleasure!

INDEX

B

Backgrounds, establishing, 82, 97-98, 108-109, 117, 122
Balance, creating, 20, 24-25
Brick, painting, 109-111

C

Clients, working with, 124-126
Color
 blending, 46-47
 gradated, on fabric, 104
 lifting, 16-17
 reflected, on fabric, 100
 See also Hair, color, building
Color, layering, 17, 81
 on eyes, 66
 on mouths, 61-62
 See also Skin tones, building
Composition, good, seeing, 23-29
Contracts, client, 124, 126

D

Drawing techniques, 21-22

E

Ear, painting an, 63
 See also Faces, painting
Edges, 15
 hair, 114
 on fabric, 105
 softening, 86, 88
Eyebrows, painting, 113, 115
 See also Faces, painting
Eyes, painting, 66-69, 71-74, 113, 122
 See also Faces, painting

F

Fabric, painting, 93-105, 120
 cotton, solid, 94-96
 denim, 99
 knits, 101-103
 patterns and plaids, 97-98, 113
 polished, 100
Faces, painting, 57-75, 113-115, 120-122
Features, painting, 57-75
 See also Faces, painting
Foliage, painting, 109-111, 114

H

Hair, 77-91
 blond, 84-86
 brown, 82-83
 brush cut, 91

color, building, 81
contrast, adding, 85
curly, 88
dark, 79-81, 111-113, 121
edges, 114
highlights, 78, 80-83, 86, 113, 122
kinky, 89
red, 87
texture, 89
wavy, 89
Highlights
 fabric, 94-96, 102-103
 hair, 78, 80-83, 86, 113, 122
 patterns, 89

L

Leaves. *See* Foliage, painting
Light
 reflected, on fabric, 104
 seeing, 31-39
 strong, painting, 34-38

M

Materials and tools, 10-11
Middle ground, painting, 118-120
Mouths, painting, 60-62, 70-73, 122
 See also Faces, painting

N

Noses, painting, 64-65
 See also Faces, painting

P

Painting
 blunders and mishaps, 127
 sequence, 108
Paper, 10
 tooth, 16, 45
Patio, painting a, 109-110
Pencils, 10
 sharpening, 11-14, 45, 79, 89
Photo shoot, planning and conducting a, 124-125
Photos, reference
 choosing, 125
 isolating values in, 49, 78
 using, 20-21
Portrait, composing a, 19-29
Portraiture, the business of, 124-126
Pricing, 126

S

Scumbling. *See* Techniques, scumbling; Techniques, "Brillo pad"

Shadows, painting, 34-38
 fabric, 96-99, 103, 113
 face, 114
 mouth, 60
Sketching. *See* Drawing techniques
Skin tone bar, making a, 47
Skin tones
 Asian, 56
 black, 53-55
 building, 45-56, 113-114, 122
 creating, 41-57, 71-75
 orange, 42
 organizing, by value groups, 44, 50
 palette guide, using a, 42
 pink, 43
 yellow, 42

T

Techniques
 blending, 46-47
 "Brillo pad," 13, 104
 See also Techniques, scumbling
 burnishing, 16
 creating edges, 15
 darks, creating, 15
 drawing, 21-22
 impressed line, 16
 layering color, 17, 61-62, 66, 81
 lifting color, 16-17
 scumbling, 13, 32
 See also Techniques, "Brillo pad"
 vertical line, 14, 32-33, 104
 wash, 45, 89, 109
Teeth, painting, 60-61
 See also Faces, painting
Texture, adding
 to fabric, 99
 to hair, 85, 89
Tools. *See* Materials and tools

V

Value scale, skin tone, making a, 47, 73
Value shapes, dividing, 78, 84
Value viewer, using a, 49, 87
Values, painting, 32-33
 ear, 74
 fabric, 94-99, 102-105
 hair, 78-90
 nose, 65
 skin tone, 44-46, 48, 73-75, 114

W

Wash technique. *See* Techniques, wash